DRAWING GALLERY

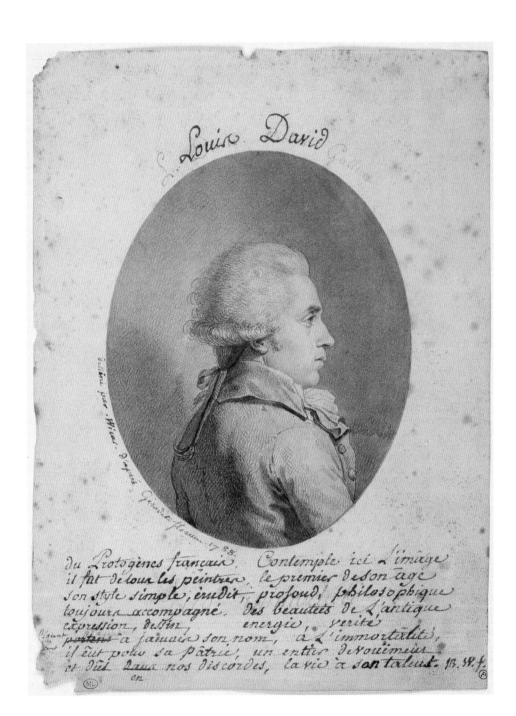

Louis David

du Protogènes français, Contemple ici l'image
il fut de tous les peintres, le premier de son âge
son style simple, érudit, profond, philosophique
toujours accompagné des beautés de l'antique
expression, dessin, energie, vérité
portent à jamais son nom, à l'immortalité,
il eut pour sa patrie, un entier devouement
et dut dans nos discordes, la vie à son talent. B.W.f.
en

LOUVRE

DRAWING GALLERY

David

Arlette Sérullaz – Louis-Antoine Prat

CONTINENTS

Cover
JACQUES-LOUIS DAVID,
*The Empress Josephine and Her
Ladies-in-Waiting* (pl. 38).

Frontispiece
JEAN-BAPTISTE JOSEPH WICAR,
*Portrait of the Painter Jacques-Louis David in an
Oval Medallion*, Paris, Musée du Louvre,
Inv. RF 51761.

© Musée du Louvre, Paris, 2005
© 5 Continents Editions srl, Milan, 2005

http://www.louvre.fr
info@5continentseditions.com

ISBN Musée du Louvre : 2-35031-024-8
ISBN 5 Continents Editions : 88-7439-250-8

For the Musée du Louvre:

Editorial Coordinator
Violaine Bouvet-Lanselle

Iconography
Christine André
Isabelle Calvi

Acknowledgements
Caroline Coujard de La Planche
Régine Dupichaud
Ludwig Speter

For 5 Continents Editions:

Translation
Susan Wise

Editorial Coordinator
Paola Gallerani

Editing
Fronia W. Simpson

Art Director
Fayçal Zaouali

Layout
Marina Longo

The paper for this publication
has been generously donated by:

ARJOWIGGINS

TABLE OF CONTENTS

"Drawing, drawing, my friend, a thousand times drawing"*

Arlette Sérullaz

David confessed that since his earliest childhood he was practically obsessed with drawing, and indeed, it was so long-lasting that he could be seen wielding a pencil up to his dying day. If we are to believe his grandson, Jacques-Louis-Jules David-Chassagnolle (1829–1886), who was the artist's first biographer, in his old age David, when not attending the theatre in Brussels, spent most of his evenings "composing and executing drawings in black pencil, some of which had been commissioned from him by publishers". We can deduce the importance David attached to his graphic work from the fact that, of the works his heirs dispersed after his death, there were far more drawings than paintings. Yet whereas the latter have become the object of passionate yet conflicting studies, this has not been the case for the drawings, which at best are considered mere working "tools" by art lovers and historians who persisted in thinking that David was a poor draughtsman. In this respect, the masterful publication owed to the perseverance of Pierre Rosenberg and Louis-Antoine Prat (2002), who established almost the entire corpus of the drawings and sketchbooks presently dispersed all over the world, came just at the right time. The conclusions of their thorough, detailed examination offer the most convincing case for revising an arbitrary judgment. So the small book you hold in your hands, for which one of those authors is in part responsible, can only appear extremely modest. Yet its ambition is great, since it hopes to inspire those who open it to examine without preconceptions the works selected for them from the collections of the Graphic Arts Department.

The first of David's drawings to enter the Musée du Louvre were purchased by the museum administration at the sale that took place on 17 April 1826 in Paris, at 4, rue du Gros-Chenet, a few months after the painter's death in Brussels. The *Catalogue des Tableaux de Galerie et de Chevalet, Dessins, Études, Livres de Croquis de M. Louis David, peintre d'histoire* [...], drawn up by M. Pérignon, featured one hundred forty entries divided into sections: first, "compositions, drawings in the heroic manner, and ancient and modern historical subjects", then "sketches for various compositions and after the antique", followed by "studies and sketches for modern subjects", "landscapes", "sketchbooks" and "studies in portfolios". According to the organisers, while the paintings should be considered "monuments both historical and authentic, as remarkable by the grandeur of the scenes they depict as by the talent and the superior genius of the artist who traced them", the master's drawings were "an object of the greatest interest", allowing us to "follow step by step [...] the progression of the one

* David to his pupil François-Joseph Navez; DAVID, 1880, p. 55.

who almost immediately raised the school from an artificial, tiresome style to a severity and a purity worthy of the great Italian masters and who varied his own manner as he wished according to the subjects he had to render". Each painting, sketch, drawing or study bore stamps and paraphs placed by David's sons, Jules and Eugène, which guaranteed the authenticity of the works and now allow us to verify their origin. Two drawings in the "heroic manner", *Homer Asleep, Two Maidens Bring Him Bread* and *Leonidas before the Battle of Thermopylae*, as well as five landscapes were bought at this sale (pls. 12, 13, 47). Because the proceeds had not met the heirs' expectations, they withdrew most of the paintings, leaving only the drawings to be auctioned, several of which they themselves purchased. Nine years later, a second sale was held in the main room of the Hôtel des Ventes, place de la Bourse, on 11 March 1835, with a significant number of the works already offered in 1826, including twelve large albums of sketches executed during David's first sojourn in Italy (1775–1780) and that had appeared in the inventory drawn up at the death of Mme David with a total estimate of 400 francs. Despite an enthusiastic description presenting these books of drawings as "the precious store of various studies and inspirations of M. David [demonstrating] in a precise manner the path he fol-

lowed to attain the great goal he had set himself, that of regenerating the school", the twelve albums did not find a buyer. Having been entrusted to Eugène David, who had died in 1830, they were placed with his widow. The museum then offered to purchase two of these large sketchbooks (pls. 2–11, 14, 15). Thus, however imperfectly, the administration made up for the mistake they made three years before—but were they even aware of it?—when they declined the offer in 1832 by Émilie Meunier, one of David's twin daughters, to sell the whole set. In their defence, the sum requested—12,000 francs—was assuredly a large one, but today we can but regret such a decision and hope it was motivated only by financial considerations. Purchasing the twelve albums would have meant possessing almost the entire monumental repertory of images David would use throughout his life, every time he conceived a grand composition, and to which his pupils as well had access. Just before leaving for exile, David leafed through them once again in the company of E.-J. Delécluze: "On seeing those painstaking attempts, those studies performed in his youth, and to which he had attached so many hopes, again and again he uttered a sigh that seemed to sum up the events that had marked the last thirty years of his life" (DELÉCLUZE, 1855, p. 349).

Subsequently, other drawings or sketchbooks that had appeared in one or the other of these sales entered the Drawing Gallery. That is the case of the drawing bequeathed by Aimé-Charles His de la Salle in 1878 (pl. 28) and of the six studies from the Jacques-Louis-Jules David-Chassagnole bequest in 1886 (pls. 16, 24, 40, 43, 45, 46). Such is equally the case for the album given in 1924 by Jacques-Michel Zoubaloff (pl. 48), one of the two albums bequeathed in 1927 by Étienne Moreau-Nélaton (pls. 31, 34), the one offered in 1932 by David David-Weill (pl. 41) and the drawing for *The Oath of the Horatii*, purchased in 1951 (pl. 19). The two albums bought in 1978 and in 1988 (pls. 20, 22, 23, 25) also come from the first David sale, which is not to overlook the sketchbook presented by the Société des Amis du Louvre in 1987 (pls. 35, 37, 39) and, just recently, the drawing *Bonaparte Standing with Horses and Horsemen behind Him* (pl. 33).

During the second half of the nineteenth century several highly valuable donations enriched the patrimony of the Musée du Louvre with extremely important drawings by David. Out of loyalty to his master, J.-A.-D. Ingres made a gift of a large preparatory study for *The Sabines*: this was the second time the Louvre received a drawing that was one of the artist's studies for one of his major paintings (pl. 32). In 1873 Jacques-Édouard Gatteaux (1788–1881) gave a design for a decoration of the curtain for the stage of the Paris Opéra, a vivid compendium of David's Revolutionary conceptions (pl. 27). Five years later, the drawings bequeathed by Aimé-Charles His de la Salle (1795–1878) included the *Homer Reciting the "Iliad" to the Greeks*, the pendant of the *Homer Asleep* purchased in 1826 (pl. 28). But in 1886 the Louvre was presented with a particularly precious bequest, coming from the master's grandson, Jacques-Louis-Jules David-Chassagnolle. The latter had stipulated in his will of 23 September 1881 that, subject to the usufruct requested by his wife, née Léonie-Marie de Neufforge (1837–1893), the Louvre would receive: "1) The Drawing of the Oath of the Jeu de Paume […] 2) The Drawing of the Distribution of the Eagles […] 3) The Drawing of the Reception of Napoleon I at the Hôtel de Ville […] 4) The Drawing of the Elder Horatius defending his son […] 5) The Drawing of the Departure of Hector […] 6) The Drawing of Venus complaining to Jupiter […]", that is, six sheets executed at different periods, generally highly finished, and affording a significant survey of the painter's various manners. Accepted by a decree of 15 February 1888, they were placed in the portfolios of the Louvre on 12 October 1893 (pls. 16, 24, 40, 43, 45, 46).

In the twentieth century the David collection of the Louvre regularly continued to be enlarged, thanks to a more active policy, at least up to World War II. The purchase in 1914 of the *Portrait of a General of the Republic* that had belonged to the marquis de Biron (pl. 30) was followed in 1917 by that of two drawings for the *Sacre*, capital evidence of the first conception of the painting and which, moreover, had already been offered to the Louvre in 1854 (pl. 36). We should particularly point out the acquisition in 1918 of a sketchbook that had belonged to the engraver Charles Normand (1814–1895), containing a great many studies for the *Horatii* as well as several intensely poetic landscapes, executed in Rome in 1784–1785 (pls. 17, 18). In 1919, thanks to the bequest of Roger Galichon (1856–1918), the *Portrait of Mademoiselle Sedaine*, whose identity has recently been questioned, adds a touch of freshness and charm to the frequently austere studies purchased up to then. Two years later, in 1921, at the ninth Alfred

Beurdeley sale, the Société des Amis du Louvre purchased for the museum a "première pensée" (first idea) for the painting of the *Sabines*. The drawing has a touching past, since it had been given by David himself to his friend the sculptor Espercieux and been carefully conserved by the latter's heirs (pl. 29).

That same year the Louvre bought from the descendants of Alexandre Lenoir the double portrait of the founder of the Musée des Monuments français and his wife (pl. 44). In 1922 the painter Léon Bonnat (1833–1922), an enlightened art lover, gave a *Study for a Figure of the "Sacre"*, as it happens, for the archchancellor Régis, duc de Cambacérès. Two years later, Jacques-Michel de Zoubaloff (1876–1941) gave an album of sketches bearing the label of Coiffier, *Marchand de couleurs et de papiers* (paint and paper dealer), who like David lived on the rue du Coq-Honoré (presently rue Marengo), that featured a series of studies for the *Distribution of the Eagles* and *Leonidas at Thermopylae* (pl. 48). In 1927 two albums, key documents for understanding the artist, were bequeathed by Étienne Moreau-Nélaton (1859–1927), who had acquired them respectively at the Hippolyte Destailleur sale (1893) and the P.-A. Chéramy sale (1908) (pls. 31, 34). Other donors of equal distinction continued this tradition of generosity. In 1931 David David-Weill (1871–1952) completed the already important collection of albums conserved in the Drawing Gallery with the donation of a sketchbook of great interest, containing studies for the *Sacre*, the *Distribution of the Eagles* and *Mars Disarmed by Venus and the Graces* (pl. 41). In 1936, among the engravings, drawings and illustrated books collected by the baron Edmond de Rothschild (1845–1934) and bequeathed by his children, James, Maurice and Alexandrine de Rothschild, was featured, among

other things, the celebrated *Marie-Antoinette Led to Her Execution* (pl. 26), which had been the property of the member of the Convention Marc-Antoine Jullien (1744–1821) and then of Jean-Louis Soulavie (1752–1813).

But we have to wait until 1951 for another drawing by David to enter the Louvre. This sheet, which had belonged to the painter L.-J.-A. Coutan (?–1830), constitutes a significant enrichment since it presents on the *recto* a study for *The Oath of the Horatii* and on the *verso* two sketches related to a painting for which the Drawing Gallery did not possess a single study: *The Lictors Bring to Brutus the Bodies of His Sons* (pl. 19).

After a long break, a marked revival in interest in David's drawings once again contributed to enrich the Louvre collections. In 1971 the bequest of Mme Pierre Goujon, née Julie Reinach (1884–1971), included the superb black pencil and graphite study *The Empress Josephine Kneeling, with Mme de la Rochefoucauld and Mme de la Valette*, which belongs to an advanced stage of the elaboration of the painting of the *Sacre* (pl. 38). In 1978 the purchase of an album, essential for the comprehension of *The Oath of the Jeu de Paume* and including as well numerous sketches related to *The Sabines* and *Leonidas at Thermopylae*, appropriately resurfaced on the occasion of the hundredth birthday of the Prouté firm; it was a felicitous complement to the small group of sketchbooks that forms the keystone of the Drawing Gallery collection (pls. 20, 22, 23). As proved by the handsome label pasted on the front cover, the artist had bought the sketchbook from the paper merchant of the Royal Academies, Niodot, whose shop, Au Chant de l'Alouette, was located on the place du Vieux-Louvre. We should mention the more recent purchase in 1985 of a study for the *Portrait of Pius VII*

that had formerly been part of one of the two albums bequeathed by Étienne Moreau-Nélaton and bearing the label of Niodot fils, who did business at Au Griffon, rue des Prêtres Saint-Germain (pl. 49), and the gift in 1987 by the Société des Amis du Louvre of an album having successively belonged to Anatole France, Édouard Mortier, fifth duc de Trévise (1883–1946) and Gilbert Lévy (1884–1944), abundantly illustrated and with a wealth of annotations attesting to the care with which David gathered detailed information on the ceremony of the anointment (pls. 35, 37, 39). In 1988 the purchase of a second sketchbook from the Gilbert Lévy collection brought highly interesting additional information regarding David's second stay in Italy. In 1995, among the drawings subject to usufruct offered by Louis-Antoine and Véronique Prat, there is a *recto-verso* sheet for *The Oath of the Jeu de Paume* (pl. 21) that the authors of the catalogue of the Edgar Degas sale had described under Eugène Delacroix's name, having probably mistaken the paraph written by Eugène David for the initials of the great master. While on the subject we should mention that the same thing happened with the album purchased in 1978 even though those sheets bore not only Eugène David's initials but also those of his brother Jules. The last of David's drawings to enter the Louvre, in 2001, is linked to a famous painting that David only sketched and that was to represent Bonaparte either after the Battle of Castiglione or at the time of the Treaty of Campo-Formio (pl. 33).

Formed over time by a succession of purchases and donations, the collection of David's drawings held at the Musée du Louvre, featuring eighteen drawings on single sheets, eight sketchbooks and two assembled albums, may appear heterogeneous and notably lacking the masterful studies of draperies that are rightly the pride of several museums in France such as the ones of Douai, Tours or Bayonne, or the curious drawings of the Brussels years, today at last being reappraised. Notwithstanding, by its variety the ensemble at the Louvre provides an essential basis for the appreciation of David's graphic work. It allows us in particular to follow with some accuracy the draughtsman's stylistic development: the first drawings date to his stay in Rome as a pensioner at the Académie de France (1775–1780) and the last were executed during his years of exile, in Brussels (1816–1825). In the same way, the multiple aspects of David's personality are revealed through highly finished drawings next to quick sketches: drawings after the Old Masters and after the antique, studies for most of the major paintings, portraits and landscapes. The variety of dimensions and subjects is matched by the variety of techniques, used separately or in combination—graphite, graphite or black pencil, red chalk (rarely, we must confess), pen, brown or grey wash, gouache. This austerity of means, obviously deliberate, which dismayed quite a few critics, did not, however, stifle the artist's sensibility; it appears in drawings with such different conceptions as the landscapes executed in Italy, several scenes inspired by the antique or even the portraits. An ardent champion of the line, continuous or broken, that for him was the indispensable plastic element in his investigations, David obviously knew how to transcribe in his cityscapes the nuances of shifting light, and how with brush and wash to obtain soft or contrasting shadows, remarkable transparencies and fluidities. In his studies related to historical subjects, usually drawn with the graphite pencil, the line sometimes surges with an astonishing impetuosity. As for the

physiognomies of his models, who could remain indifferent to the intense life they express?

Even more than the single-sheet drawings, the two assembled albums and the sketchbooks deserve special attention. The drawings mounted on the pages of the assembled albums faithfully reflect the great amount of labor David expended to break with the courtly, conventional repertory dear to Boucher's followers. To grasp the transformation of a graphic style that constantly corrects itself, that progresses in apparently contradictory and illogical stages, we must take the time to examine the copies David made during the five years of his sojourn in Italy. They are the evidence of an eclectic curiosity. In Rome, David copied everything he could see in the museums and the churches, as well as in the collections conserved in the palaces and villas: the antiquities, of course, and the Old Masters (Raphael, the seventeenth-century Bolognese painters, but as well Poussin, Le Sueur, Bordone, Sebastiano del Piombo, Mola, Lanfranco, Gaulli, Veronese, Salviati, etc.). Furthermore, we gradually discover that these studious exercises reflect the determination to preserve for posterity something entirely different from a mere repertory of models and forms established in conformity with the instruction imparted at the Académie de France. The time spent in this exercise may have been excessive, but while he was performing it, the copyist was not content to reproduce literally the models selected at random in the course of his strolls. Far from it, since we now know that David had collated his drawings in accordance with a precise order, unfortunately distorted after his death by the intervention of his sons, which is unfortunate, to say the least. It is clear that this "grammar of forms" provided him with a great deal of material for his future compositions. In this respect, the albums are full of precious information: there are the first ideas of the subject contemplated as well as the attempts to organise a composition, not to mention the highly accurate studies for such or such group of figures or isolated figure. Constantly on hand, continuously used, set aside to be picked up again depending on a whim of invention (or an unforeseen obstacle), they are the confidant but also the witness of the hesitations of the painter in the grip of the agony of creation, of his sudden impulses, that will be subsequently rejected, altered and controlled as his work progresses.

Time after time David claimed that the artist must be capable of thinking, in other words, of offering the viewer exemplary actions by supporting the exemplarity of the subject with that of the interpretation. The corrections he performs in the course of elaborating his major paintings should not be seen as proof of an aborted reflection but instead as the maturation of a thought that gradually becomes more precise, at the cost of a lengthy progress. Indeed, Philippe de Chennevières was fully aware of this, proud of having in his collection the most dazzling synthesis "of the store of studies and sketches and first ideas, and of groups and fragments of the capital composition [*The Sabines*] that for so many years absorbed the concern of the master and his studio" (1897, pp. 414–447).

This aspiration to greatness and simplicity that guided David all his life was rarely understood, as we have already pointed out. His many detractors were so self-confident in blacklisting him as one of those second-rate draughtsmen, lacking in imagination, cold and static, that they stifled the voices of those who admired him for his self-imposed asceticism.

The poor reception given to David's graphic work probably stems from an overly literal interpretation of his doctrine and the artist's insistence on the forma-

tive role of drawing: to sustain his conception, he rejected any kind of appeal to certain graphic techniques he deemed too seductive, and replaced the sensuality of colour by the rigour of graphite, graphite pencil or pen. He was reproached for never having yielded to "the pleasure of the line for the sake of the line, the line cast by an imaginative hand, the line where the red chalk or lead pencil catches on the 'teeth' of rough paper, the type of line we might call the paraph line, the colour line, the texture line" (HAUTECŒUR, 1954, pp. 297–298). In the same way, critics derided his blind admiration for antiquity, "the great school of modern painters", which led him to devote himself almost exclusively to the illustration of heroic themes. In so doing, they gradually forgot that the artist, as soon as he felt he had acquired full mastery of his hand, was able to set his drawing to the task of the great works commissioned from him or that he had chosen to execute on his own.

Undoubtedly, we cannot put an end to this controversy, arisen during the artist's lifetime, merely by presenting fifty works on paper. We hope that all those who will take the trouble to open this book will appreciate the originality of a draughtsman who sought to make his ideal equal to the most contemporary reality. Steeped in antique models—without being enslaved by them—David, as paradoxical as it may seem, sometimes succeeds in blending with the greatness of style and the nobility of conception that characterise most of his drawings a feeling for the truth that is already realistic, a touch of melancholy and anxiety that is not devoid of romanticism. In the overall evolution of his art, drawing played a decisive role, catalysing his lifeblood as a painter and revealing to us his most intimate thoughts.

Chronology

1748 30 August: birth in Paris, quai de la Mégisserie, of Jacques-Louis-Maurice David, son of the haberdasher and dealer in textiles Louis-Maurice David and Marie-Geneviève Buron.

1758–1764
He studies with a tutor whose pupils are enrolled in the Collège de Beauvais. In second grade one of his teachers notices his gift for drawing. He studies the top classical form at the Collège des Quatre-Nations and attends the life drawing studio of the Academy of Saint Luke.

1766 On the advice of Boucher, to whom he was introduced by his uncle François Buron, David becomes the pupil of Joseph-Marie Vien, professor at the Academy school since 1759. In September he is enrolled in the Academy as "protégé of M. Vien".

1773 September: he receives the "award for the study of heads and expression", founded by the comte de Caylus, for his figure *Grief* (Paris, École nationale supérieure des Beaux-Arts).

1774 March: for the fourth time David enters the competition for the Grand Prix de Rome for painting, which he wins with *Erasistratus Discovers the Cause of the Illness of Antiochus* (Paris, École nationale supérieure des Beaux-Arts).

1775 2 October: departs for Rome, with Vien, who has been appointed director of the Académie de France. In the course of the five years of his sojourn in Italy, David draws continuously, after the Old Masters, after the antique and from life. He executes several paintings including *Saint Roch Interceding for the Plague-stricken* (Marseille, Musée des Beaux-Arts).

1781 24 August: accepted at the Academy on presenting *Belisarius Receiving Alms* (Lille, Musée des Beaux-Arts), which he exhibits at the Salon.

1782 16 May: marries Marguerite-Charlotte Pécoul, daughter of a contractor and superintendent of royal constructions, with whom he has four children: Charles-Louis-Jules (1783), François-Eugène (1784) and the twins Laure-Émilie-Félicité and Pauline-Jeanne (1786).

1783 23 August: received at the Academy with *Andromache Mourning Hector* (Paris, Louvre), which he exhibits at the Salon.

1784 Early September: returns to Rome with three pupils: Drouais, Wicar and Debret, to execute M. d'Angiviller's commission for the king: *The Oath of the Horatii* (Paris, Louvre).

1789 August: exhibits at the Salon *The Loves of Paris and Helen*, commissioned by the comte d'Artois, and *The Lictors Bring to Brutus the Bodies of His Sons* (Paris, Louvre) commissioned by the king.

1790 29 December: following a session of the club of the Jacobins, David is commissioned to make a painting commemorating the Oath of the Jeu de Paume. The work was not completed.

1793 21 January: death of Louis XVI. David is among those who voted for the king's execution. On 14 September he is appointed a member of the *Comité de sûreté générale*. He is in charge of organising various ceremonies, one of which is in honour of the removal of Marat's ashes.

1794 27 July: fall from power of Robespierre. On 2 August David is arrested and taken to the Hôtel des Fermes, which has been turned into a prison, then to the Luxembourg, where he is able to work. He is released on 28 December.

1795 29 May: arrested a second time, is taken to the Collège des Quatre-Nations, then set free. For reasons of health, he is allowed to retire to his brother-in-law's. He does the latter's portrait and that of his wife (Paris, Louvre).

1797 He works on organising the Musée Central des Arts (now the Musée du Louvre) and the exhibition of masterpieces brought from Italy.

1799 21 December: presents at the Louvre the painting *The Sabines*, introducing the principle of charging an admission fee (this one lasted five years and earned him proceeds of more than 70,000 F).

1801 14 June: visit of the First and the Third Consul (Bonaparte and Lebrun) to David's studio and the exhibition of *The Sabines*.

1803 18 December: David is made *chevalier* of the Legion of Honour.

1804 2 December: at Notre-Dame attends the anointing of Napoleon, who engages him to execute the paintings commemorating the celebrations of the Anointing and the Coronation. Two out of four will be executed. On 18 December he is named First Painter to the Emperor.

1808 14 October: exhibits at the Salon the *Sacre* (Paris, Louvre) that the Emperor and the Empress had come to see in his studio. On 22 October he is made *officier* of the Legion of Honour and *chevalier* of the Empire.

1810 4 August: wins the competition for the decennial prizes with *The Coronation of Napoleon.* Exhibits at the Salon *The Distribution of the Eagle Standards* (Versailles, Musée national du Château).

1815 March: on his return from the island of Elba, Napoleon visits David in his studio in the Cluny church and praises him for *Leonidas at Thermopylae* (Paris, Louvre). On 6 April, David is promoted to *commandeur* of the Legion of Honour. Between 23 July and 17 August, he journeys to Switzerland and Savoy in search of a refuge, following the return to Paris of King Louis XVIII.

1816 12 January: vote of article 7 of the amnesty law concerning the banishment of the regicides. On 27 January David arrives with his wife in Brussels, where he meets his former Belgian pupils. He continues to paint up to his death: *Cupid and Psyche* (1817, Cleveland, The Cleveland Museum of Art), *The Farewell of Telemachus and Eucharis* (1818, Los Angeles, J. Paul Getty Museum), *The Anger of Achilles* (1819, Fort Worth, Kimbell Art Museum).

1820 26 January: through the agency of David's solicitor and business manager, Jean-Louis Delahaye the elder, the royal museums purchase *The Sabines* and *Leonidas*, which are exhibited at the Luxembourg in Paris.

1821 November: Gros visits his master and presented him with a gold medal expressing "the gratitude of the French School".

1824 May: David sends to Paris *Mars Disarmed by Venus and the Graces* (Brussels, Musées royaux des Beaux-Arts de Belgique) to be exhibited for one year. Despite Gros's entreaties, he refuses to undertake proceedings that would enable him to return to France.

1825 29 December: death of David. Eugène David asks Gros to take the required steps to obtain permission to bury his father in France, but the authorities of Brussels wish to keep the artist's remains.

1826 16 February: funeral of David in the church of Sainte-Gudule. On 11 October his remains are buried in the cemetery of Saint-Josse-en-Noode.
17–20 April: sale of David's works in Paris, in an auction room at 4, rue du Gros-Chenet. On 9 May, death of Mme David.

1835 10 March: second sale of David's works in Paris, at the auction room of the Hôtel des Ventes, place de la Bourse.

1882 17 September: removal of David's tomb and remains to the new cemetery, located in the commune of Evere, near Brussels (a patron has extended the concession until 2021).

PLATES

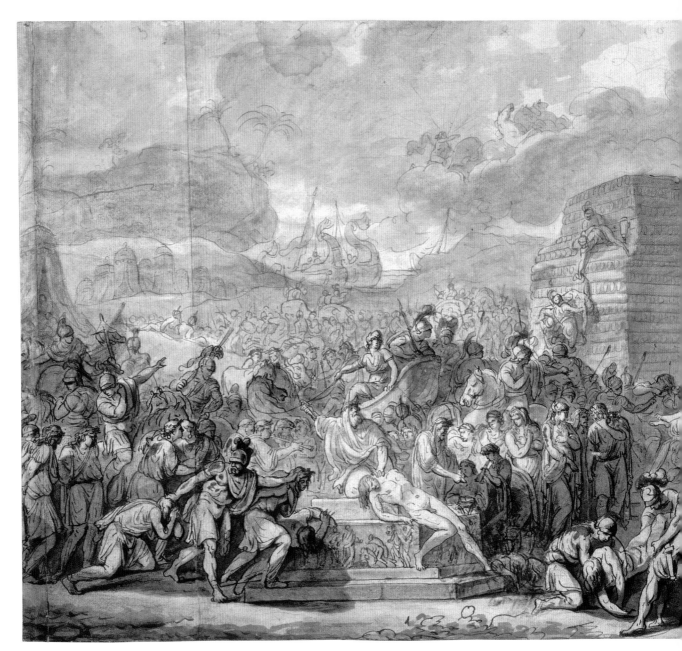

1. *The Burial of Patroclus*

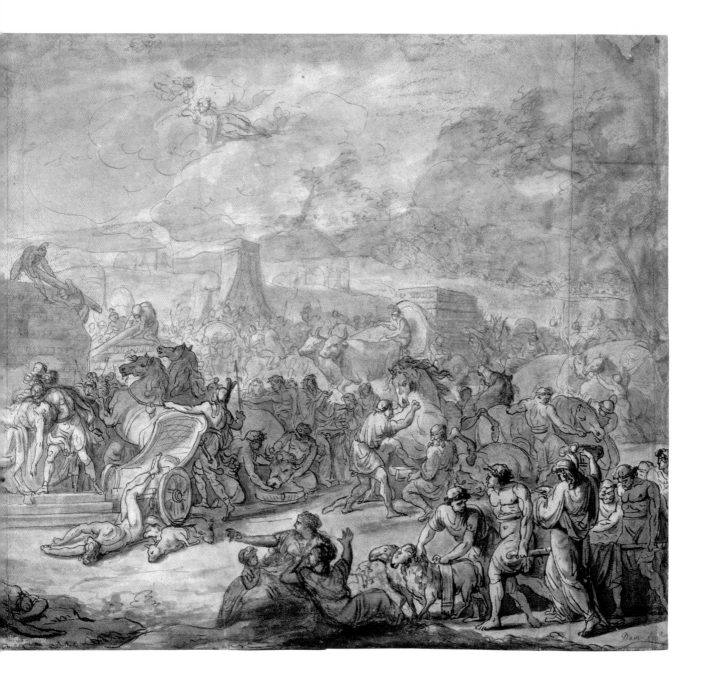

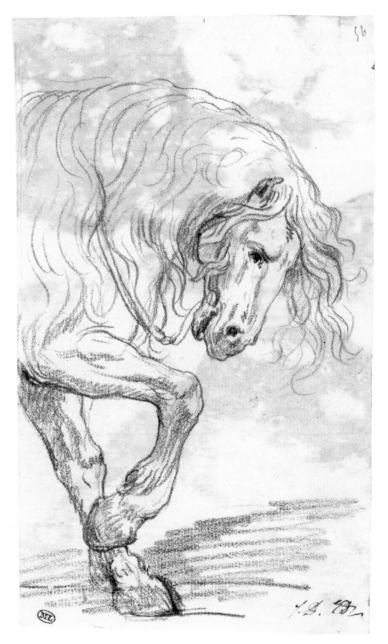

2. *Forequarters of a Horse, in Right Profile*

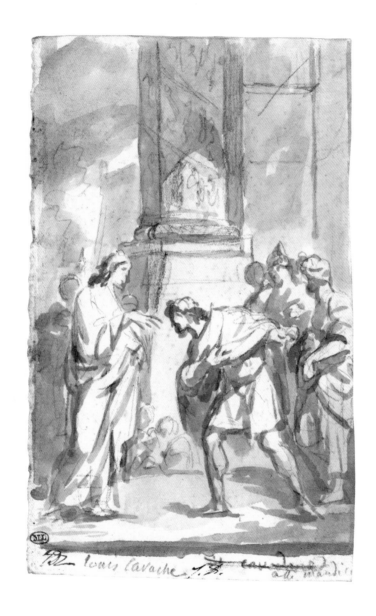

3. *The Calling of Saint Matthew, after Ludovico Carracci*

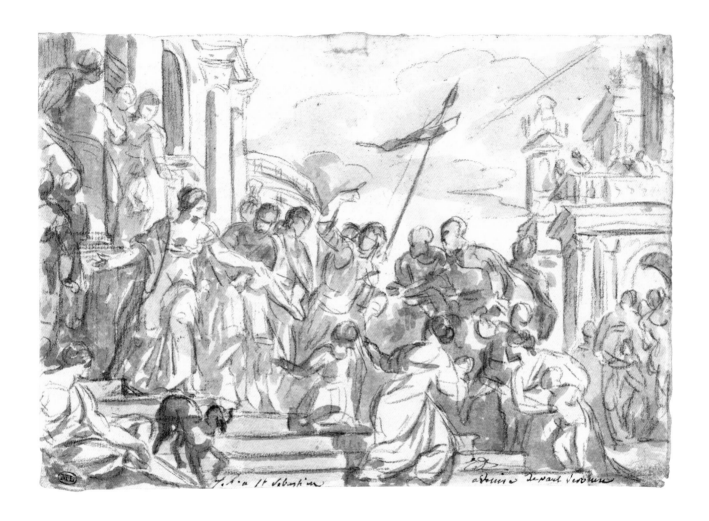

4. *Saint Martin and Saint Marcellin Led to Martyrdom, after Veronese*

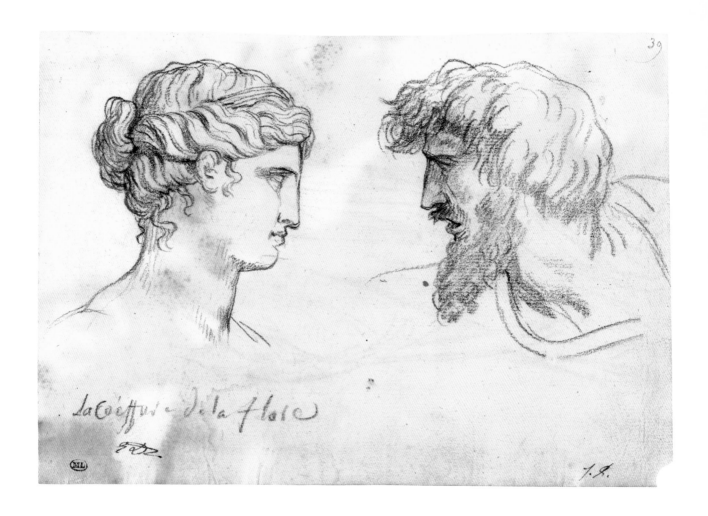

5. *Head of the Farnese Flora; Head of a Bearded Man, after Raphael*

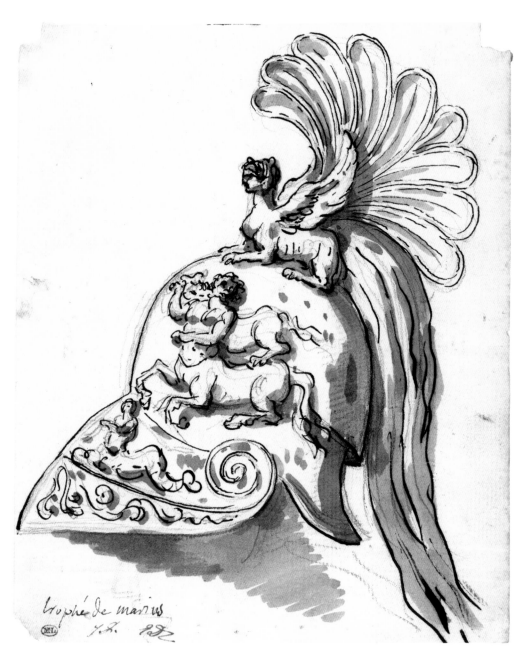

trophée de marius

6. *Antique Helmet Adorned with a Female Sphinx and a Plume*

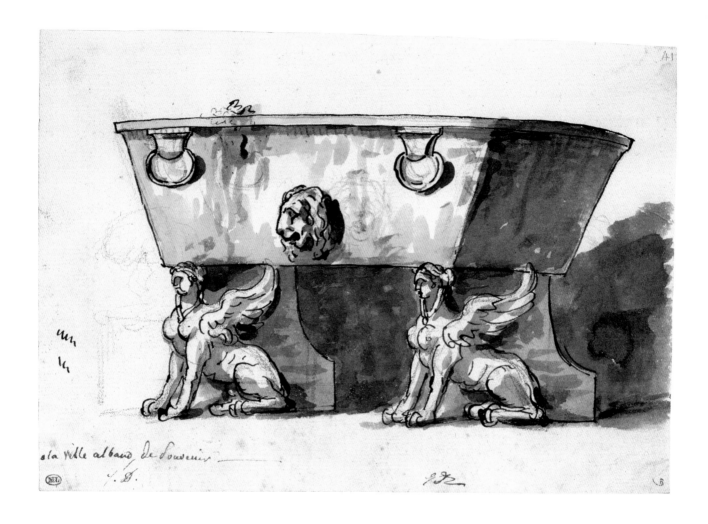

7. *Basin Resting on Two Sphinx-Shaped Plinths*

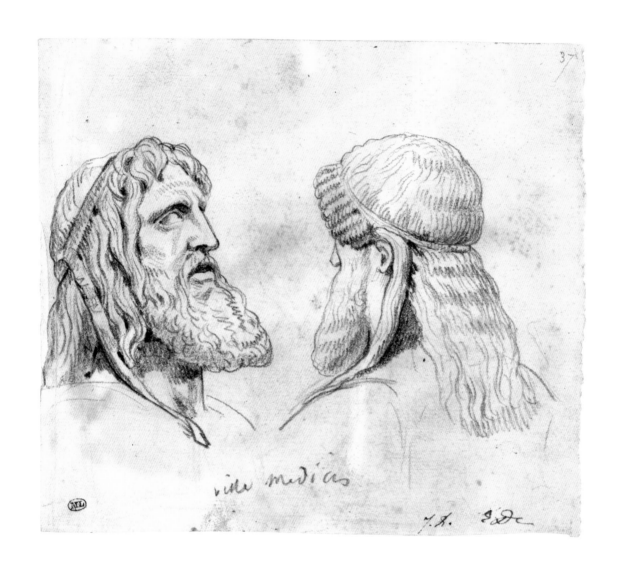

8. *Two Half-Lengths of Men at the Villa Medici*

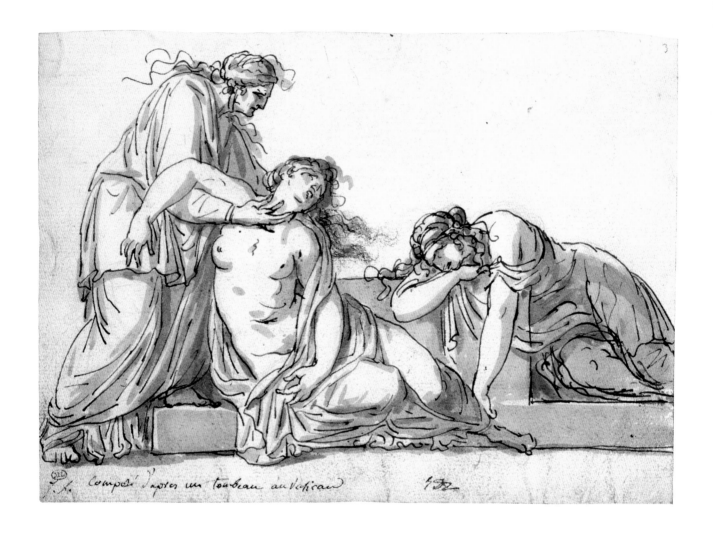

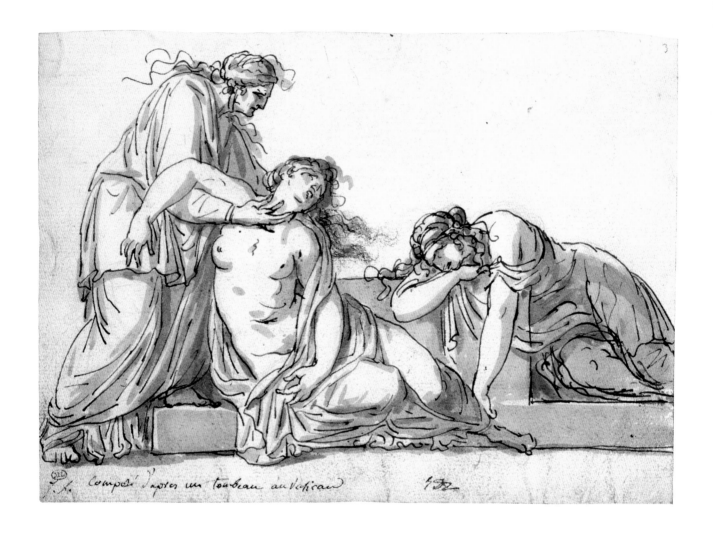

9. *Old Woman Holding up a Nude Woman, Partly Reclining; Recumbent Woman, Bent Forward Toward the Left*

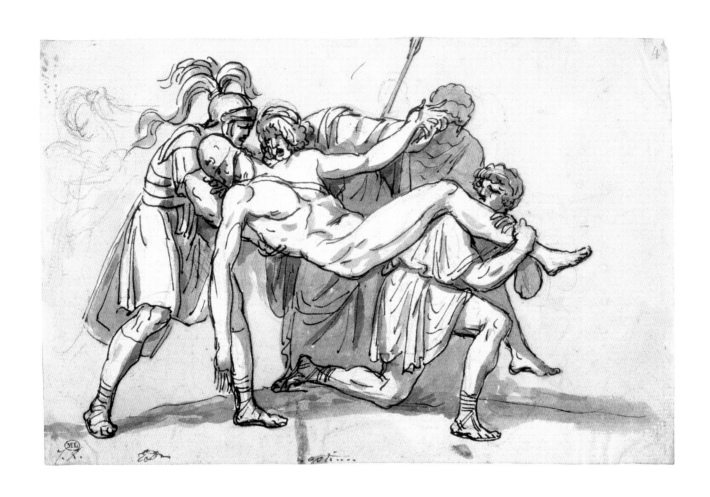

10. *The Death of Meleager*

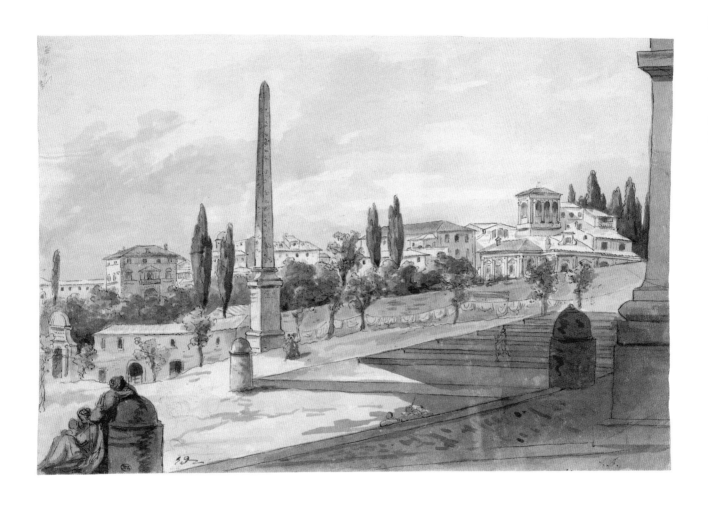

11. *View of Rome with the Piazza dell'Esquilino*

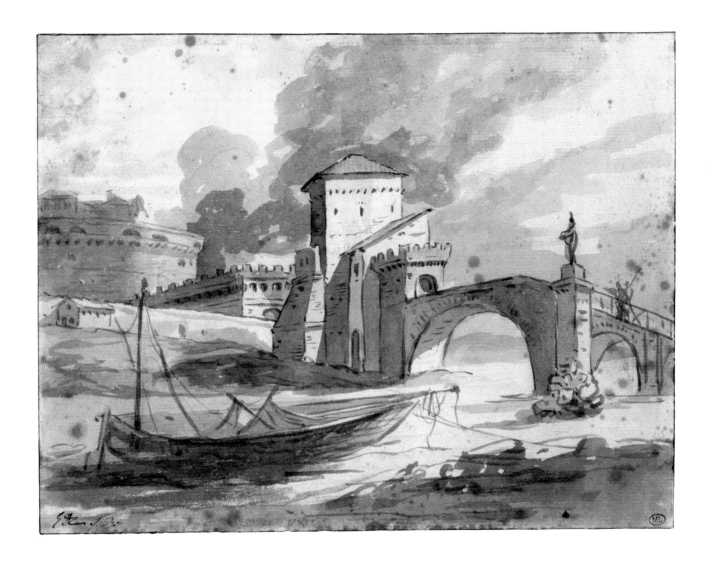

12. *Roman Landscape with the Tiber and Castel Sant'Angelo*

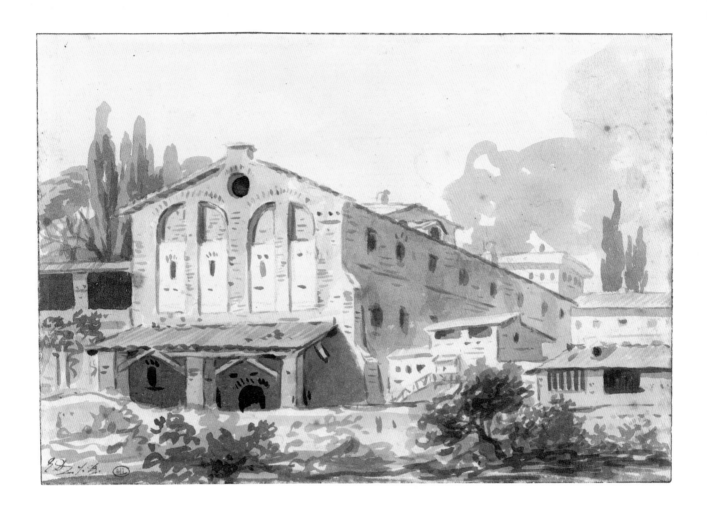

13. *A Mill in Italy*

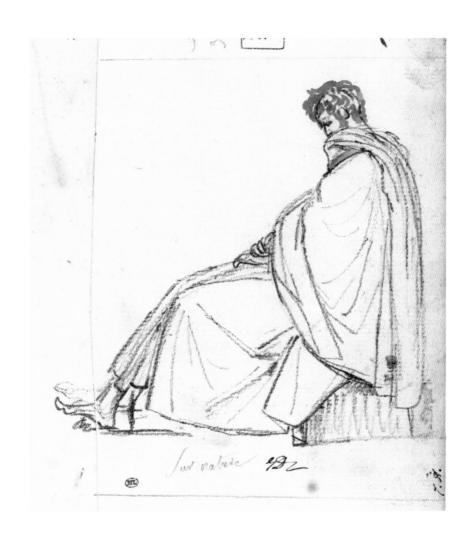

14. *Man Seated, Draped, in Profile and Facing Left*

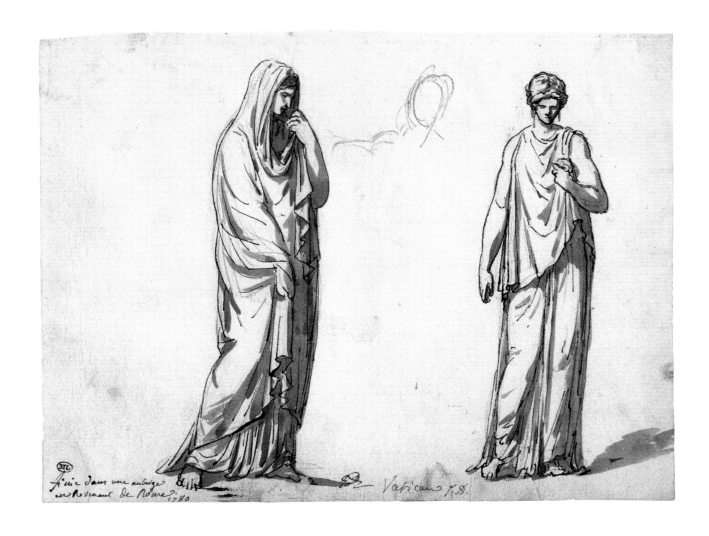

15. *Draped Woman, in Right Profile; Nemesis Seen Frontally, Her Head Lowered; Faint Sketch of a Head* (?)

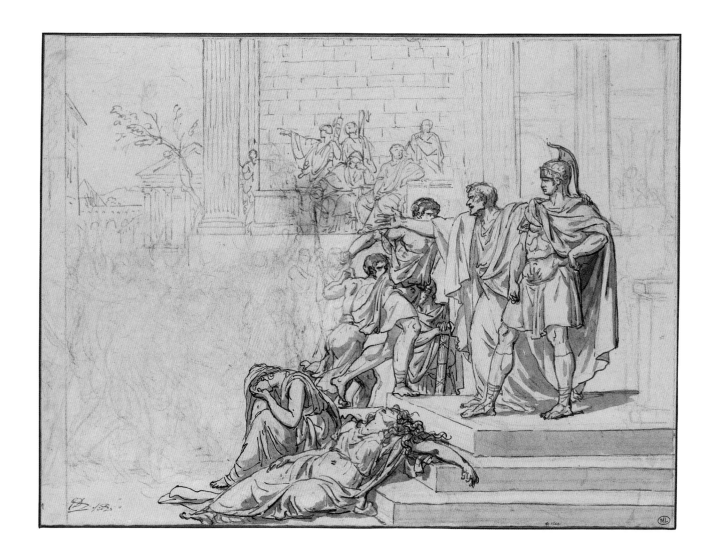

16. *The Elder Horatius Defending His Son after the Death of Camilla*

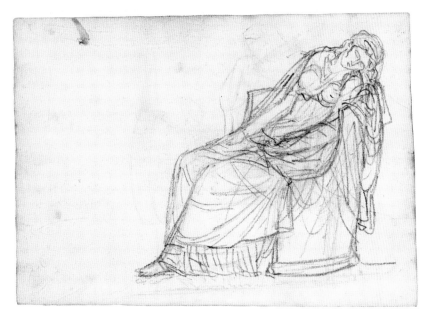

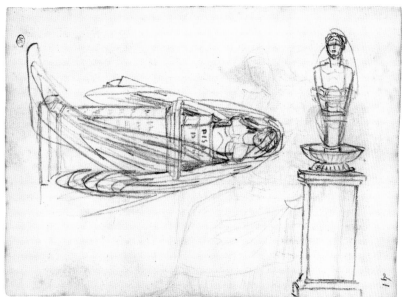

17. *Two Sketchbook Pages: Woman Reclining in a Chair, Her Head Facing Right, and Faint Sketch of a Woman;*
Two Busts Placed on Plinths and Faint Sketch of a Woman

18. *Sketchbook Page: View of the Church of San Saba in Rome*

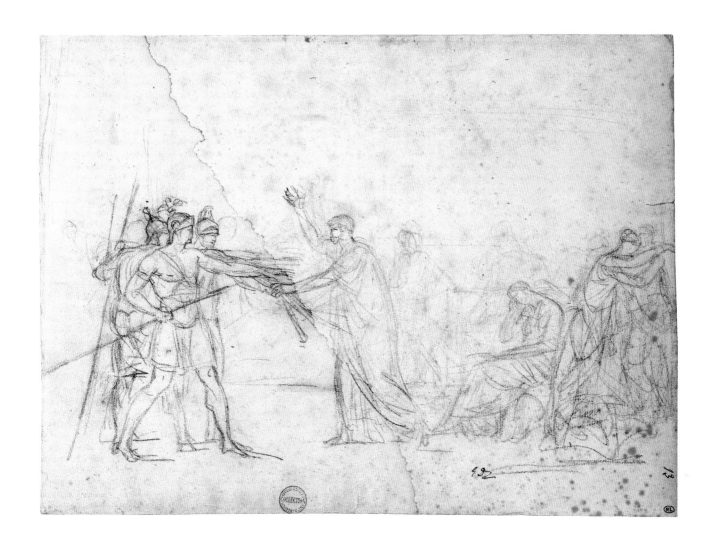

19. *The Oath of the Horatii*

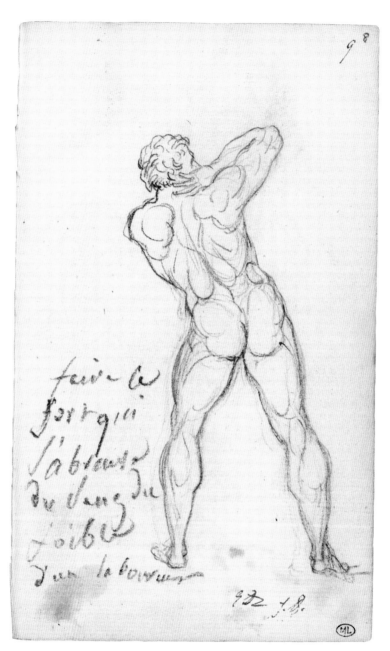

20. *Sketchbook Page: Nude Man Seen from Behind, after Michelangelo*

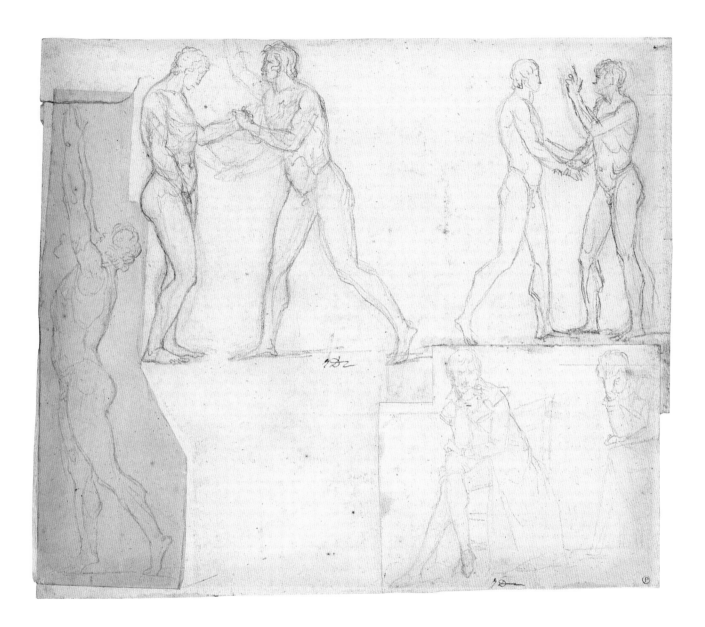

21. *Studies of Figures for the Oath of the Jeu de Paume*

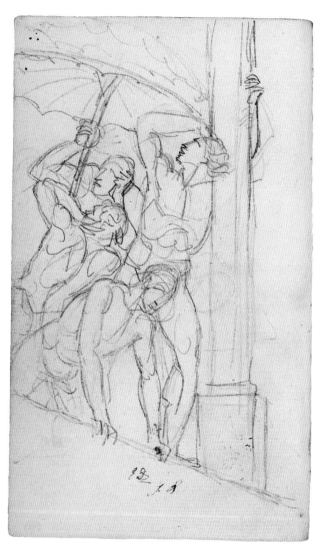

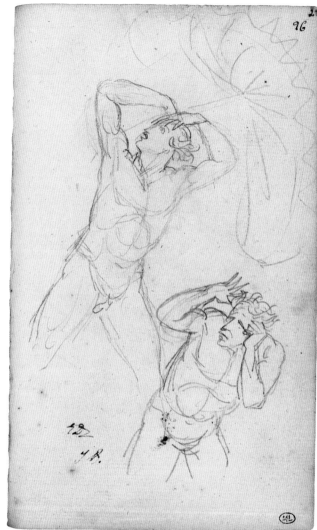

22. *Two Sketchbook Pages: Group of Four Nude Men One of Whom Holds an Umbrella; Two Nude Men, Arms Raised, Three-Quarters Left*

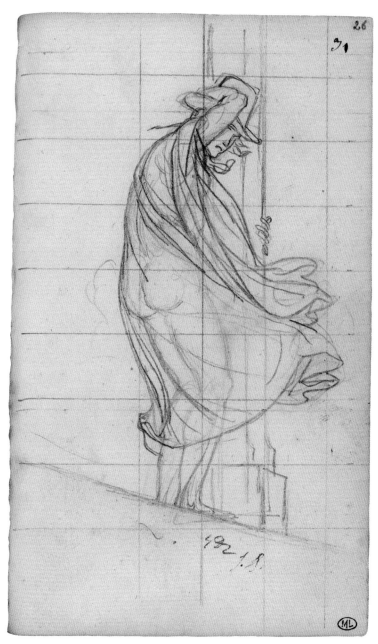

23. *Sketchbook Page: Man Seen from Behind, Three-Quarters Right, Holding onto His Hat and Gripping a Pillar*

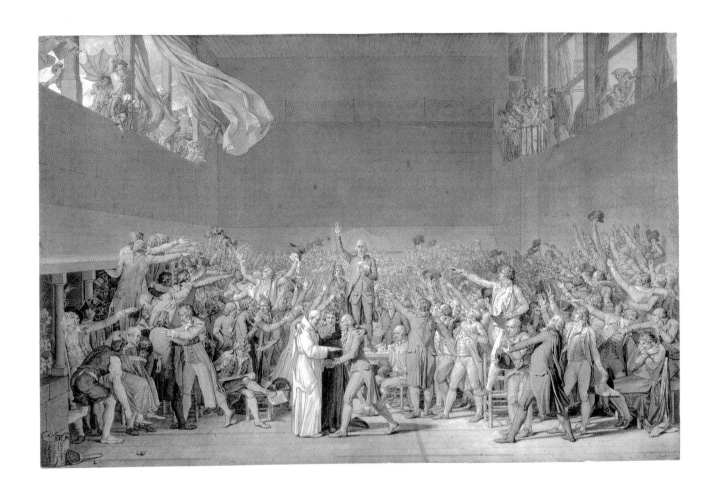

24. *The Oath of the Jeu de Paume*

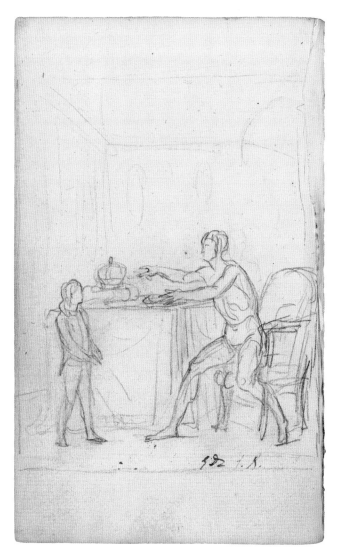

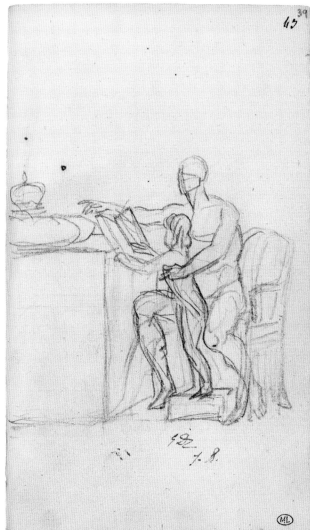

25. *Two Sketchbook Pages: A Man and a Child near a Table*

26. *Marie-Antoinette Led to Her Execution, Seated in Left Profile*

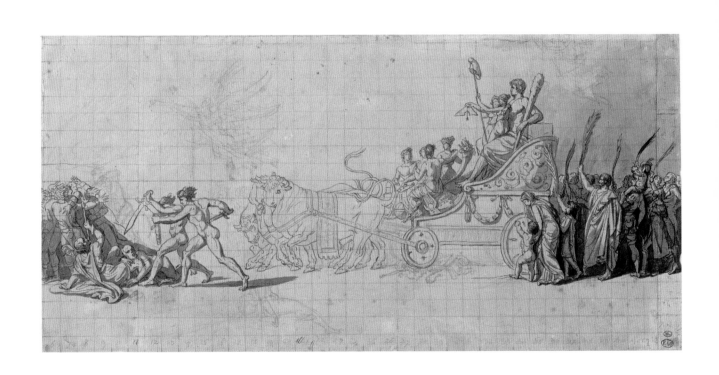

27. *The Triumph of the French People*

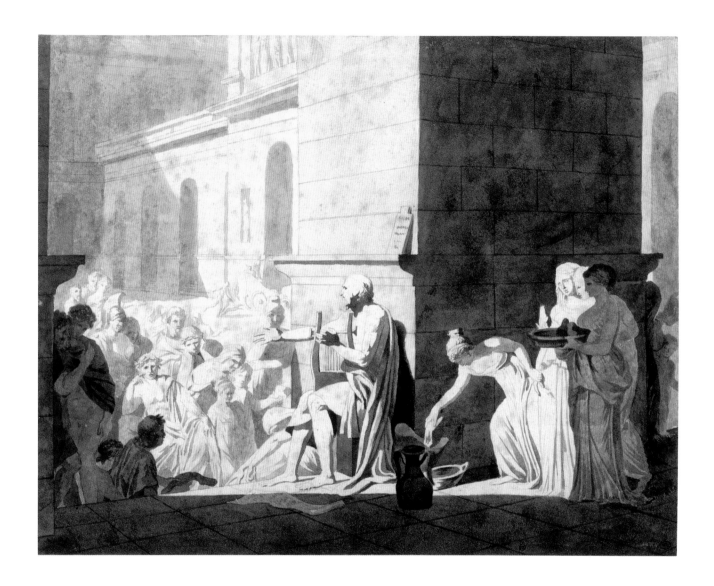

28. *Homer Reciting the "Iliad" to the Greeks*

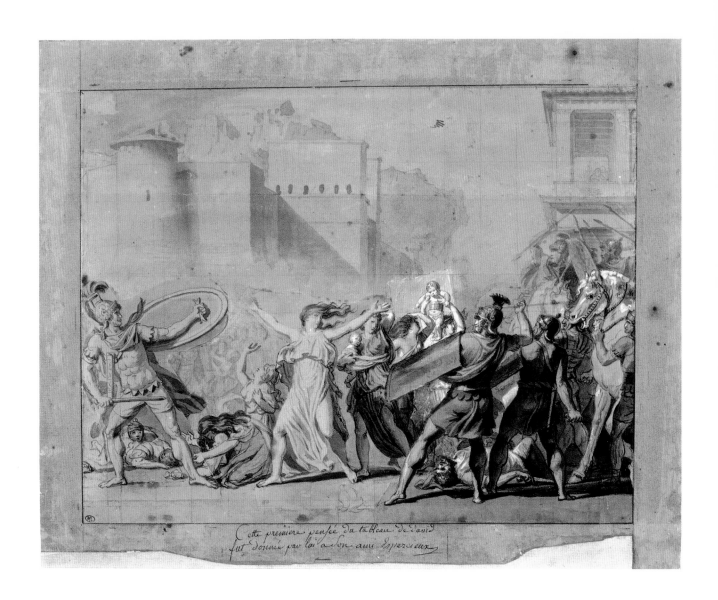

29. *The Intervention of the Sabine Women*

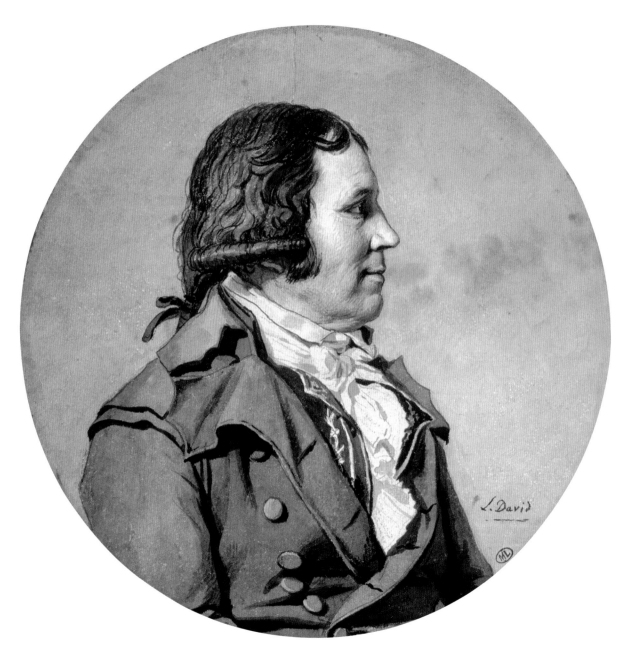

30. *Portrait of an Unknown Person, Half-Length, Right Profile*

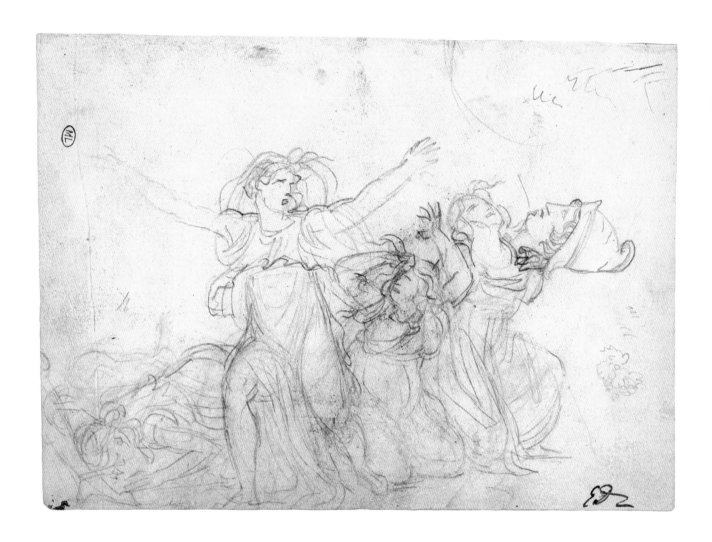

31. *Sketchbook Page: Group of Four Women and Head of a Man in Left Profile*

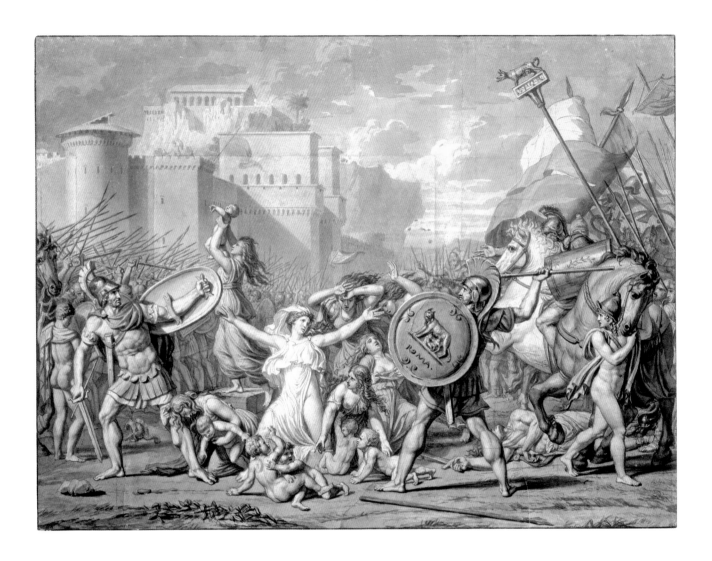

32. *The Intervention of the Sabine Women*

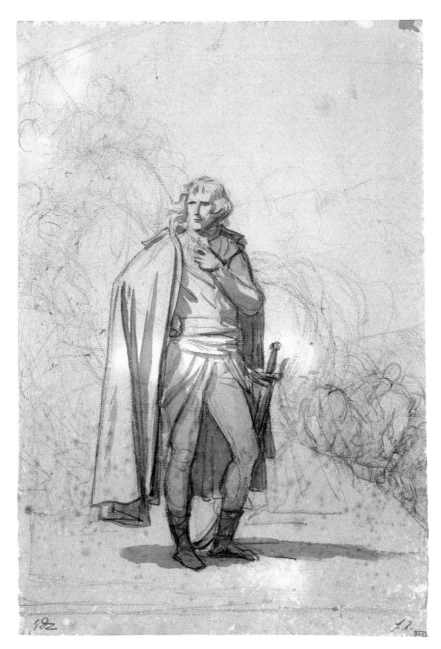

33. *Bonaparte Standing, with Horses and Horsemen behind Him*

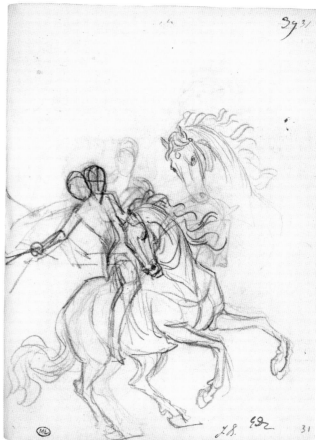

34. *Two Sketchbook Pages: Studies of Horses and Horsemen*

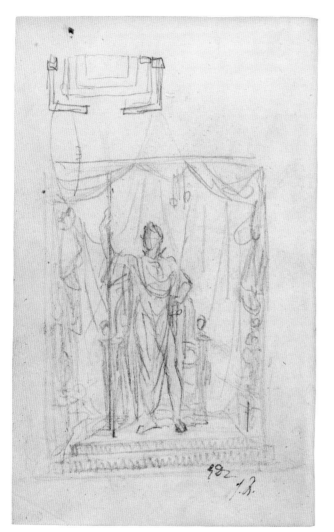
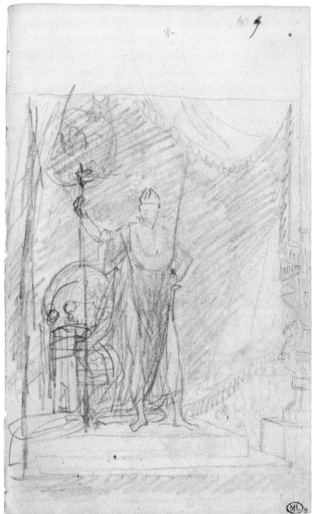

35. *Two Sketchbook Pages: Napoleon Standing in Front of a Throne*

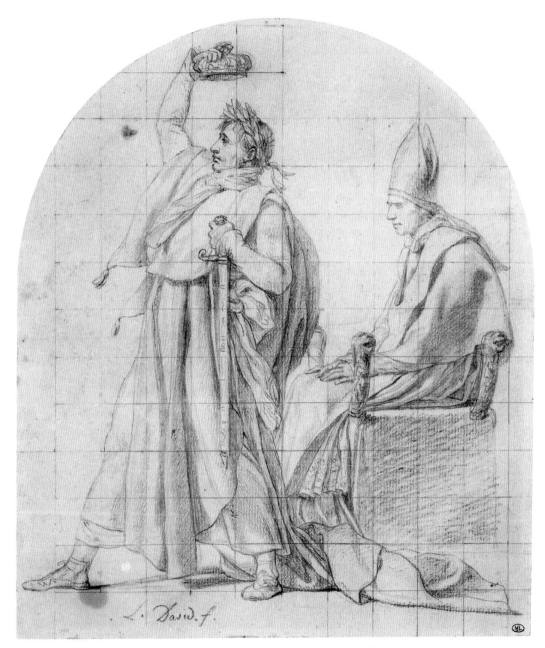

36. *Napoleon Crowning Himself, Pope Pius VII Seated behind Him*

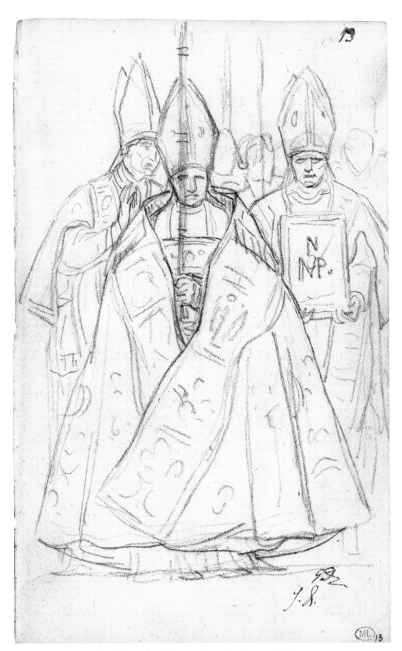

37. *Sketchbook Page: Three Prelates, Full-Front*

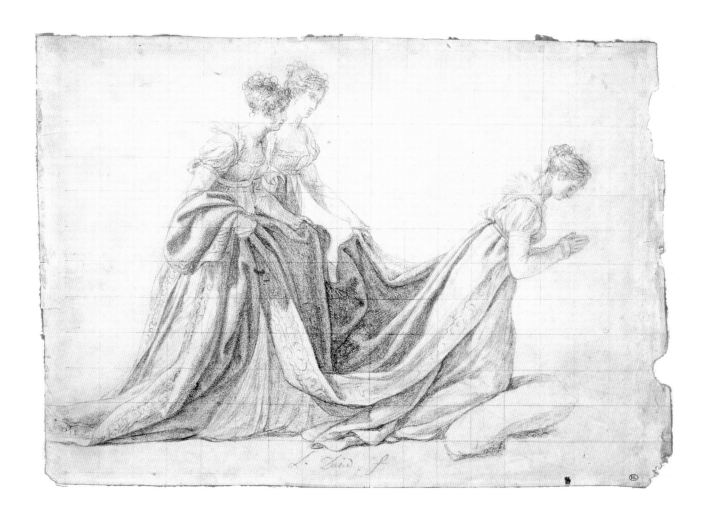

38. *The Empress Josephine and Her Ladies-in-Waiting*

39. *Two Sketchbook Pages: Couple Striding toward the Right and Man in Left Profile; Studies of Ecclesiastics and Nude Man*

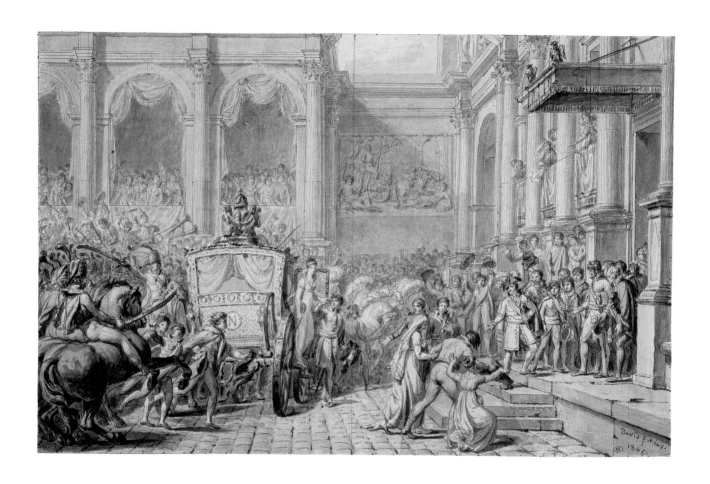

40. *The Reception of the Emperor and the Empress at the Hôtel de Ville of Paris*

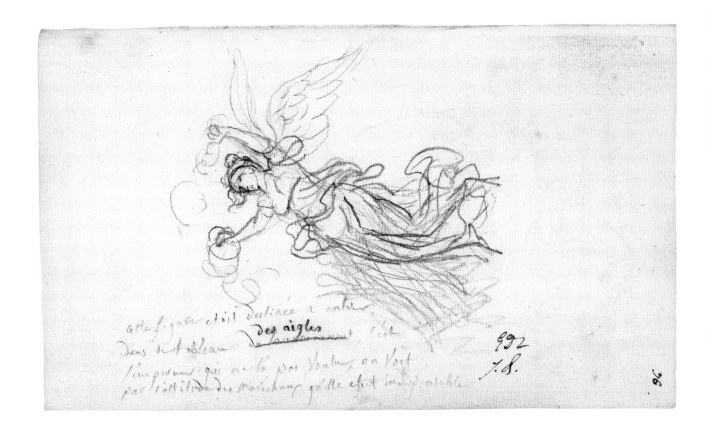

cette figure etoit destinée a entrer
Dans le Tableau Des aigles
l'impereur qui ne les pas Voulu, on Voit
par l'attitude des Maréchaux qu'elle etoit indispensable

992
J.S.

98

41. *Sketchbook Page: Victory in Flight toward the Left*

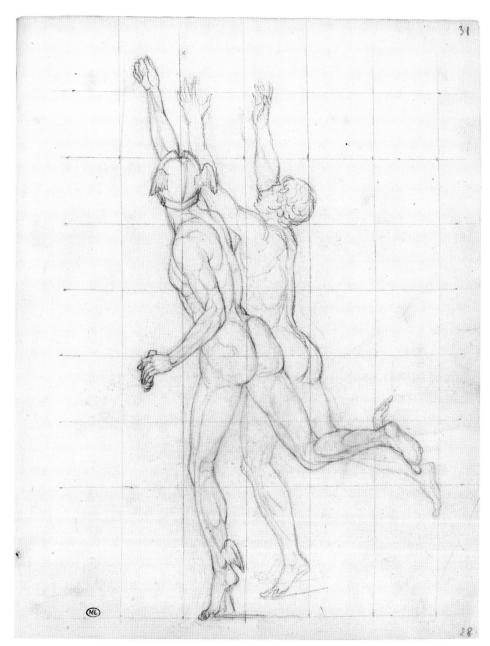

42. *Sketchbook Page: Two Nude Men Running toward the Left*

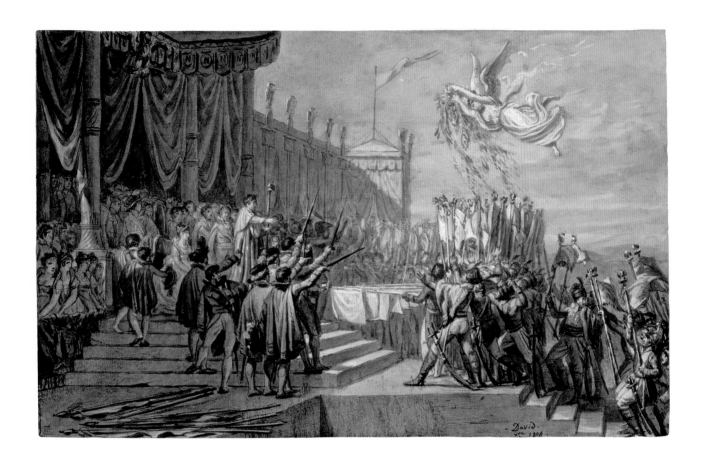

43. *The Distribution of the Eagle Standards*

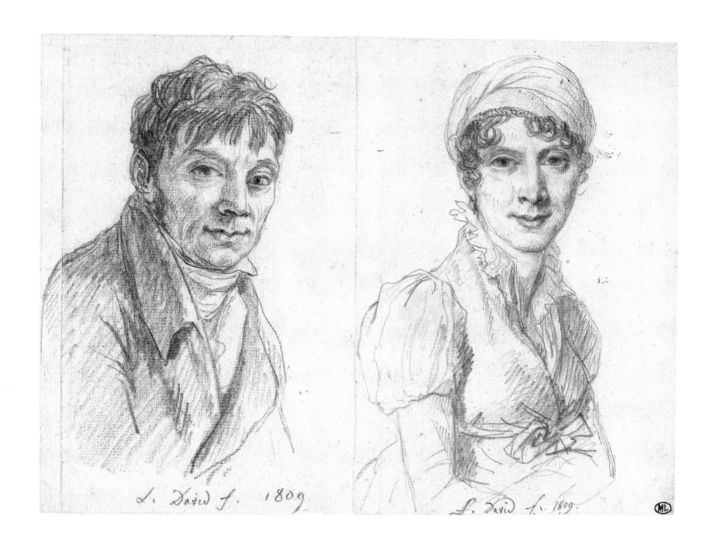

44. *Portrait of M. and Mme Alexandre Lenoir*

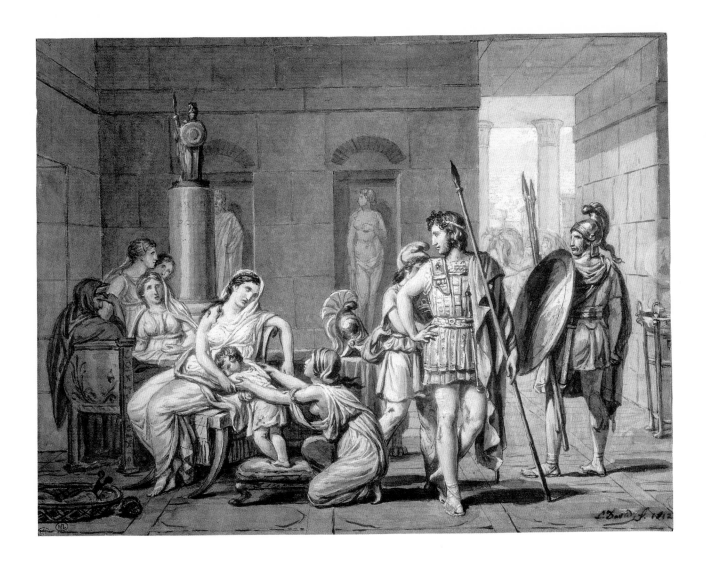

45. *The Departure of Hector*

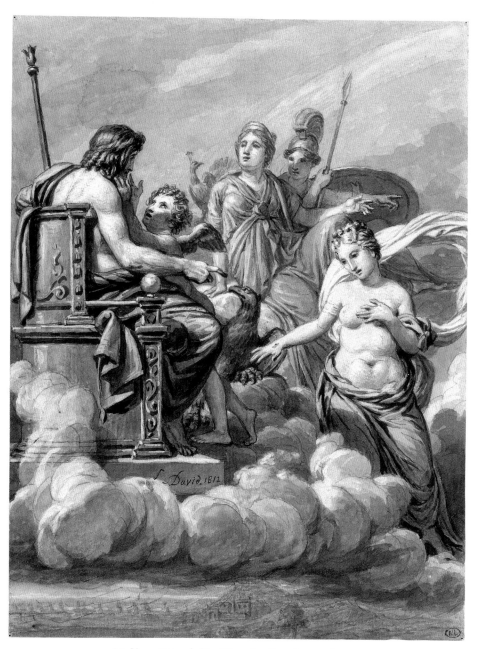

46. *Venus Wounded by Diomedes Complains to Jupiter*

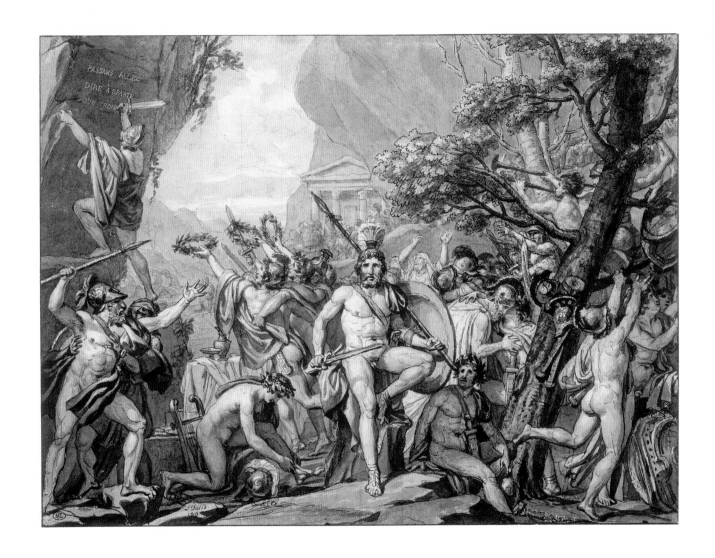

47. *Leonidas at Thermopylae*

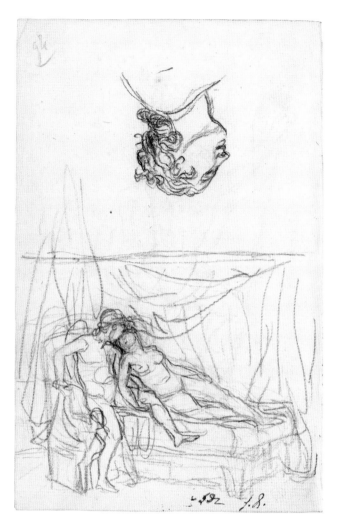
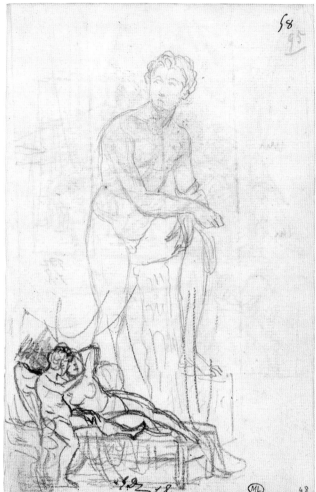

48. *Two Sketchbook Pages: Cupid and Psyche*

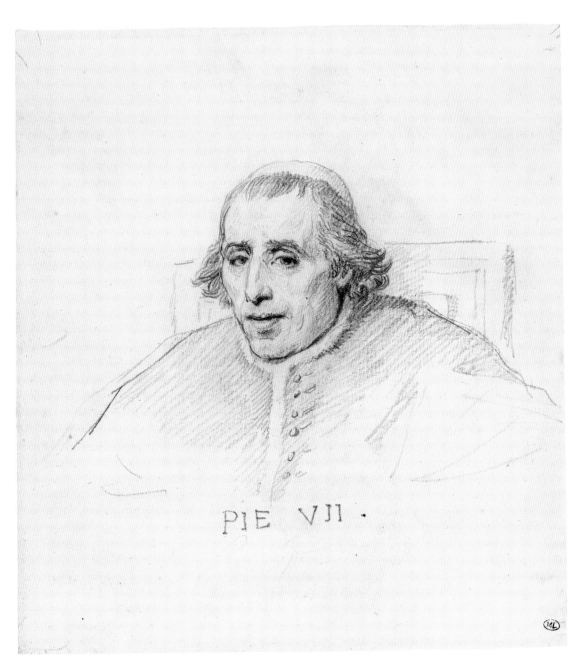

49. *Portrait of Pope Pius VII*

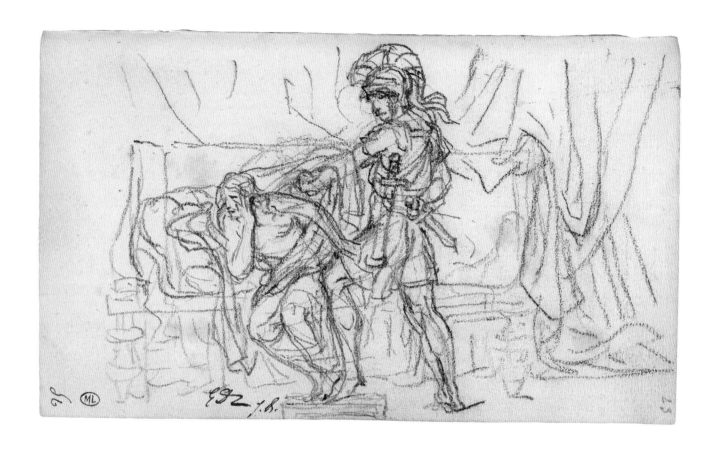

50. *Sketchbook Page: The Rape of Lucretia*

CATALOGUE

CATALOGUE

Entries by Louis-Antoine Prat

1. *The Burial of Patroclus*
Pen, black and brown inks, grey wash and oxidised white heightening over black chalk sketch, on four joined sheets of paper. Signed in pen and brown ink lower right: *David f R.* On the verso, in red chalk and red chalk wash, with traces of black pencil, *Male Academy and Fragment of Another Sketch.* 33.0 × 75.5 cm. Inv. RF 4004

After more than three years in Rome, in September 1778 David completed his composition of *The Burial of Patroclus*, a horizontal painting in a persistently neo-baroque style (Dublin, National Gallery of Ireland). The subject is drawn from Homer's *Iliad* and shows Achilles bringing to his friend's funeral pyre the dead body of the Trojan prince Hector. Another study for the same composition, preserved in the Honfleur museum, is far less accurate; the poorly defined aspect of the composition, thronged with too many unrelated groups, still denotes David's affiliation with eighteenth-century art.
Prov.: Entered the Louvre ca. 1896 (?). SÉRULLAZ, 1991, no. 190, repr.; ROSENBERG and PRAT, 2002, no. 28, repr.

2. *Forequarters of a Horse, in Right Profile*
Black chalk. 17.4 × 10.3 cm. Inv. 26112

Copy, probably executed during the first Roman sojourn, of a detail of an engraving or a tapestry woven after one of Rubens's compositions for the series illustrating the life of the Roman consul Decius Mus, *Decius Consecrates Himself to the Infernal Gods*; David will put a very similar horse in the large equestrian portrait *Count Stanislaw Potocki* that he will complete in Paris in 1781 (Warsaw, National Museum).

Prov.: Mounted on fol. 14 of reassembled album 7, purchased by the Louvre at the second David sale, Paris, 11 March 1835, part of no. 16. SÉRULLAZ, 1991, no. 2, repr.; ROSENBERG and PRAT, 2002, no. 787, repr.

3. *The Calling of Saint Matthew, after Ludovico Carracci*
Brush, grey wash over black chalk. Black chalk inscription, in David's hand, lower left: *louis carache* and lower right: *cavedone* (crossed out) *alle mendica*[nti]. 14.4 × 9.0 cm. Inv. 26130 *ter*

One of the many copies David executed after the Italian masters during his first Roman sojourn; later, in a passage of his *Autobiography*, he would express regret for having been influenced by baroque painting for such a long time. The painting by Ludovico Carracci (1555–1619), executed for the Salaroli Chapel of the Church of Santa Maria dei Mendicanti in Bologna, is presently in the Pinacoteca of that city; David went through Bologna on his way back to France in 1780.
Prov.: Mounted on fol. 2 of reassembled album 9, purchased by the Louvre at the second David sale, Paris, 11 March 1835, part of no. 16. SÉRULLAZ, 1991, no. 2, repr.; ROSENBERG and PRAT, 2002, no. 925, repr.

4. *Saint Martin and Saint Marcellin Led to Martyrdom, after Veronese*
Red chalk, brush and grey wash. Pen and black ink inscription, in David's hand, at lower edge: *a St Sebastien a Venise de paul Veronese.* 11.8 × 17.1 cm. Inv. 26087

Copy after a famous composition by Paolo Veronese (1528–1588) in the Church of San Sebastiano in Venice, where it still is today;

it was executed by David in 1780 on his way back to France; the artist omitted several details of the original (an angel on the left, a small monkey near a column).

Prov.: Mounted on fol. 3 of reassembled album 7, purchased by the Louvre at the second David sale, Paris, 11 March 1835, part of no. 16. SÉRULLAZ, 1991, no. 20, repr.; ROSENBERG and PRAT, 2002, no. 742, repr.

5. *Head of the Farnese Flora; Head of a Bearded Man, after Raphael*
Black chalk. Black chalk inscription, in David's hand, lower left: *La coéffure de la flore* and upper right: 39. On the verso, in black chalk, general view of the Farnese Flora, seen from behind and in three-quarters left. 13.1 × 19.1 cm. Inv. 26103 *bis*

By placing side by side on the same sheet the copy of a famous antiquity, the Farnese Flora (in Naples since 1783–1786; today in Naples, Museo Archeologico Nazionale), and that of a detail of Raphael's *School of Athens*, one of the most admired of the Vatican *Stanze* frescoes, David expressed a whole artistic credo, the very one that his most renowned pupil, Jean-Auguste-Dominique Ingres, would exclusively adhere to. The two copies were probably not executed at the same time, and the dialogue between them sought by the copyist is all the more meaningful.

Prov.: Mounted on fol. 9 of reassembled album 7, purchased by the Louvre at the second David sale, Paris, 11 March 1835, part of no. 16. SÉRULLAZ, 1991, no. 15r, repr.; ROSENBERG and PRAT, 2002, no. 770r, repr.

6. *Antique Helmet Adorned with a Female Sphinx and a Plume*
Pen, black ink, brush, brown wash over black chalk. Black chalk

inscription, in David's hand, lower left: *trophée de marius.* 19.2 × 18.5 cm. Inv. 26106.

Here, sometime between 1775 and 1780, David copied a detail of one of the reliefs known as the Trophies of Marius, now on the Piazza del Campidoglio in Rome. Warriors wearing similar helmets can be seen in the large drawing, dated to 1776, of the *Battles of Diomedes* (Vienna, Albertina; ROSENBERG and PRAT, 2002, no. 12, repr.) as well as in the painting *The Burial of Patroclus* (see no. 1).

Prov.: Originally mounted (and presently dismounted) on fol. 11 of reassembled album 7, purchased by the Louvre at the second David sale, Paris, 11 March 1835, part of no. 16. SÉRULLAZ, 1991, no. 59, repr.; ROSENBERG and PRAT, 2002, no. 777, repr.

7. *Basin Resting on Two Sphinx-Shaped Plinths*
Pen, black ink, brush, grey wash over black chalk. Pen and black ink inscription, in David's hand, lower left: *a la villa albano, de Souvenir* and upper right: *41.* 14.8 × 21.1 cm. Inv. 26105

As David himself admits, the copy was not drawn from life; therefore, it presents many discrepancies with respect to the model, a basin in the manner of the antique, presently placed in the gardens of the Villa Albani in Rome. Recollections of this object, combined with a throne from the Vatican, can be seen in the bed in the background of the painting kept in the museum in Lille, *Apelles Painting Campaspe.*

Prov.: Mounted on fol. 10 of reassembled album 7, purchased by the Louvre at the second David sale, Paris, 11 March 1835, part of no. 16. SÉRULLAZ, 1991, no. 62, repr.; ROSENBERG and PRAT, 2002, no. 772, repr.

8. *Two Half-Lengths of Men at the Villa Medici*
Black chalk. Black chalk inscription, in David's hand, lower center: *villa medicis* and upper right: 37. On the verso, in black chalk, copy of *Agrippina Seated* in the Museo Capitolino, Rome. 13.2 × 15.1 cm. Inv. 26102 *bis*

On several occasions between 1775 and 1780 David copied busts placed in the gardens of the Villa Medici in Rome: the one on the right is now lost; the one on the left is still there but in poor condition.
Prov.: Mounted on fol. 9 of reassembled album 7, purchased by the Louvre at the second David sale, Paris, 11 March 1835, part of no. 16. SÉRULLAZ, 1991, no. 77r, repr.; ROSENBERG and PRAT, 2002, no. 768r, repr.

9. *Old Woman Holding up a Nude Woman, Partly Reclining; Recumbent Woman, Bent Forward Toward the Left*
Pen, brown ink, brush, grey wash over black chalk. Pen and brown ink inscription, in David's hand, lower left: *composé d'après un tombeau au Vatican* and upper right: 3. 15.2 × 21.2 cm. Inv. 26084

It was but a short time after its discovery in 1776 that David copied, or rather interpreted, two details of the sarcophagus of the Niobids presently in the Vatican. The juxtaposition of two motifs separated on the actual object (one is on the coffin, the other on the lid) and "flavoured with the modern sauce", to quote the artist's words, would almost have us believe it is a compositional drawing invented by David. His favourite pupil, Jean-Germain Drouais, also copied the group of the two women on the left, in a drawing conserved in the museum of Bourges.
Prov.: Mounted on fol. 1 of reassembled album 7, purchased by the Louvre at the second David sale, Paris, 11 March 1835, part of no. 16. SÉRULLAZ, 1991, no. 90r, repr.; ROSENBERG and PRAT, 2002, no. 734, repr.

10. *The Death of Meleager*
Pen, brown ink, brush and grey wash over black chalk; faint black chalk sketch upper left. Pen and brown ink inscription, in David's hand, lower centre: *goti…* 13.9 × 21.3 cm. Inv. 26084 *bis*

The source appears to be a sarcophagus of the same subject but with a coarser treatment, conserved at the Palazzo Mattei in Rome;

the figures are stockier, and neither Meleager nor the man on the left is wearing a helmet; the group will be reutilised by David in one of the largest compositional drawings he ever made, *Frieze in the Antique Manner*, representing the death and burial of a hero, presently shared by the museums of Sacramento and Grenoble (ROSENBERG and PRAT, 2002, no. 34, repr.).
Prov.: Mounted on fol.1 of reassembled album 7, purchased by the Louvre at the second David sale, Paris, 11 March 1835, part of no. 16. SÉRULLAZ, 1991, no. 112, repr.; ROSENBERG and PRAT, 2002, no. 735, repr.

11. *View of Rome with the Piazza dell'Esquilino*
Pen, black ink, brush, grey wash over black chalk. 20.5 × 31.0 cm. Inv. 26111

Aside from copies after the antique and the Old Masters, the Roman albums all contain lovely studies of Italian landscapes, executed between 1775 and 1780, especially in Rome. Here, David stood at the corner of the Santa Maria Maggiore basilica to draw the obelisk at the centre of the stairs leading to the church, as well as the Villa Montalto Negroni in the background.
Prov.: Mounted on fol. 13 of reassembled album 7, purchased by the Louvre at the second David sale, Paris, 11 March 1835, part of no. 16. SÉRULLAZ, 1991, no. 169, repr.; ROSENBERG and PRAT, 2002, no. 786, repr.

12. *Roman Landscape with the Tiber and Castel Sant'Angelo*
Brush, grey wash over black chalk. 16.6 × 22.0 cm. Inv. 26082

A view, probably imaginary, of a Rome reconstituted by David during his first Italian sojourn.
Prov.: Purchased by the Louvre at the David sale, Paris, 17 April 1826 and following days, part of no. 64 (with three other drawings of landscapes, including no. 13). SÉRULLAZ, 1991, no. 170, repr.; ROSENBERG and PRAT, 2002, no. 22, repr.

13. *A Mill in Italy*
Brush, grey wash and white heightening over black chalk. 15.0 × 21.8 cm. Inv. 26082 *bis*

Executed during the Roman sojourn of 1775–1780.

Prov.: Purchased by the Louvre at the David sale, Paris, 17 April 1826 and following days, part of no. 64 (with three other drawings of landscapes, including no. 12). Sérullaz, 1991, no. 178, repr.; Rosenberg and Prat, 2002, no. 25, repr.

14. *Man Seated, Draped, in Profile and Facing Left*
Black chalk, brush and grey wash. Between two vertical framing lines in black chalk, perhaps drawn by David. The drawing is executed directly on fol. 13 of album 9, and the sitter's feet extend onto the drawing mounted in the album to its left, representing a scene of lamentation. Black chalk inscription, in David's hand, lower centre: *sur nature*. 15.9 × 12.7 cm. Inv. 26159

The drawing was obviously executed by David after he arranged his two large Roman albums (subsequently divided into twelve), since it is on top of a drawing mounted previously on fol. 13. We wonder if it dates to the period of the first Roman sojourn or is later; in any case, it inspired the figure of Plato to the left in *The Death of Socrates* of 1787 (New York, Metropolitan Museum of Art). The annotation "from life", that David will inscribe on other occasions on figure sketches, does not allow us to date it with more accuracy.
Prov.: Executed on fol. 13 of reassembled album 9, purchased by the Louvre at the second David sale, Paris, 11 March 1835, part of no. 16. Sérullaz, 1991, no. 182, repr.; Rosenberg and Prat, 2002, no. 984, repr.

15. *Draped Woman, in Right Profile; Nemesis Seen Frontally, Her Head Lowered; Faint Sketch of a Head* (?)
Pen, black ink, brush and grey wash over black chalk. Pen and black ink inscriptions, in David's hand, lower left: *finie dans une auberge / en Revenant de Rome. 1780* and at centre: *Vatican*. 15.2 × 21.0 cm. Inv. 26143 *bis*

These two copies after the antique (on the left, detail of a relief of a sarcophagus in the Vatican representing the Rape of the Daughters of Leucippus, on the right a statue of Nemesis, also in the Vatican) were doubtless drawn from life in black chalk, then later corrected in wash, during the return journey to Paris, as attested by David's inscription.
Prov.: Mounted on fol. 8 of reassembled album 9, purchased by the Louvre at the second David sale, Paris, 11 March 1835, part of no. 16. Sérullaz, 1991, no. 88, repr.; Rosenberg and Prat, 2002, no. 949, repr. (the annotation is reproduced as fig. 3 of the introduction)

16. *The Elder Horatius Defending His Son after the Death of Camilla*
Black chalk (partly erased) and pen, black ink, brush and grey wash. 21.8 × 28.9 cm. Inv. RF 1917

Shortly after his return from Rome in 1780, David, inspired by both Livy and Corneille, contemplated a composition devoted to the story of the Roman hero Horatius. He first thought of depicting him victorious over the Curiatii, returning to Rome and striking his sister Camilla (several drawings, including one dated to 1781 at the Albertina in Vienna, Rosenberg and Prat, 2002, no. 48, repr.); then, in 1782, he devised the present composition, which was not translated into a painting. He gave it up because of the criticism of a friend, the dramaturgist Sedaine, who supposedly told him: "The action you have chosen is almost nonexistent, it is nothing but words". In any case, the drawing reflects the influence of the great classicizing painters, Poussin as well as Domenichino. David ultimately settled on an earlier episode in the story of Horatius, that of the oath (see nos. 17 and 19).
Prov.: David sale, Paris, 17 April 1826 and following days, no. 41; purchased by David's heirs; Jules David-Chassagnolle bequest to the Louvre in 1886. Sérullaz, 1991, no. 191, repr.; Rosenberg and Prat, 2002, no. 50, repr.

17. *Two Sketchbook Pages: Woman Reclining in a Chair, Her Head Facing Right, and Faint Sketch of a Woman; Two Busts Placed on Plinths and Faint Sketch of a Woman*
Black chalk. 18.8 × 13.5 cm (each). Inv. RF 4506

In 1784 David returned to Rome to prepare his large painting *The Oath of the Horatii* (Paris, Louvre, 1785) for which this sketchbook features several studies; the left page prepares the figure of Sabina, Horatius's wife, on the right of the composition; we also make out a very faint sketch for the figure of Camilla in the same painting; on the right page, another faint sketch for one of the two women; one of the statues on a plinth announcing the representation of Rome (or Urbs) that will appear in a painting executed four years later, the *Brutus* of 1789 (Paris, Louvre).

Prov.: Fols 40v and 41r of sketchbook 2*, purchased from the widow of Charles Normand by the Louvre in 1918. SÉRULLAZ, 1991, no. 224, repr.; ROSENBERG and PRAT, 2002, nos. 1323v and 1324r, repr.

18. *Sketchbook Page: View of the Church of San Saba in Rome*
Brush, grey wash over black chalk. 13.5 × 18.8 cm. Inv. RF 4506

Executed during the artist's second Roman sojourn, between October 1784 and August 1785. The same sketchbook contains several other views of Roman edifices. David's favourite pupil, Jean-Germain Drouais, had accompanied him to Rome on this occasion and would help him in the preparation of *The Oath of the Horatii*; he also copied, practically by his master's side, several Roman buildings (Rennes, Musée des Beaux-Arts), and the drawings by the two artists are at times amazingly similar.
Prov.: Fol. 71r of sketchbook 2 (see no. 17). SÉRULLAZ, 1991, no. 224, repr.; ROSENBERG and PRAT, 2002, no. 1354r, repr.

19. *The Oath of the Horatii*
Black chalk. On the verso, in black chalk with a few pen and brown ink highlights, *Two Studies of a Group of Two Maidens Holding up a Woman*. 25.9 × 35.4 cm. Inv. RF 29914

In this quite advanced study (probably late 1784) for his large painting, David has almost realized the final composition, but the three Horatii brothers are not yet placed one behind the other with the rigour of a low relief, and the father's gesture lifting up the bound swords has not yet been found. As for the female figures on the right, in the painting they will all be seated, forming a far more harmonious group. The sketches on the verso prepare the group of the wife and daughters of Brutus in the painting of 1789, *The Lictors Bring to Brutus the Bodies of His Sons* (Paris, Louvre).
Prov.: David sale, Paris, 17 April 1826 and following days, perhaps no. 45; L.-J.-A. Coutan; Hauguet; Coutan-Hauguet sale, Paris, Hôtel Drouot, 16–17 December 1889, no. 96; purchased by the Louvre from Mme Craemer in 1951. SÉRULLAZ, 1991, no. 194, repr.; ROSENBERG and PRAT, 2002, no. 68, repr.

20. *Sketchbook Page: Nude Man Seen from Behind, after Michelangelo*
Black pencil. Black pencil inscription, in David's hand, lower left:

faire le / fort qui / s'abreuve / du sang du / foible / d'un laboureur.
18.2 × 11.3 cm. Inv. RF 36942

Here David copied a figure of the *Conversion of Saint Paul* by Michelangelo in the Pauline Chapel of the Vatican, reversed with respect to the original fresco and therefore after an engraving. The annotation on the drawing shows that he thought of using this figure for a composition, never completed, that he planned in 1789–1790, *The Allegory of the Revolution at Nantes*, a city in which he lived for a month beginning in mid-March 1790. Several other drawings of the same sketchbook and single sheets (ROSENBERG and PRAT, 2002, nos. 103–105) are probably preparatory for the same project.
Prov.: Fol. 8r of sketchbook 4, whose provenance may be the 1826 David sale; L.-J.-A. Coutan; Hauguet; Coutan-Hauguet sale, Paris, Hôtel Drouot, Paris, 16–17 December 1889, no. 118; Galerie Paul Prouté, Paris; purchased by the Louvre in 1978. SÉRULLAZ, 1991, no. 226, repr.; ROSENBERG and PRAT, 2002, no. 1444r, repr.

21. *Studies of Figures for the Oath of the Jeu de Paume*
Graphite pencil on three sheets of paper, including an unevenly shaped counter-drawing, mounted on the recto of one of the two other joined sheets. On the verso, in graphite pencil, a nude man, arms raised, in left profile. 24.5 × 28.5 cm. Inv. RF 44330

In all probability this is one of the first sketches for the central group (and other details) of *The Oath of the Jeu de Paume*, a project commissioned from David by the Jacobins in October 1790 (see no. 24). The two principal drawings prepare the group of the three ecclesiastics at the centre of the composition, but here we see only two of them, dom Gerle and Rabaut Saint-Étienne. The two sketches at lower right can be compared to several figures of seated men in no. 24. As for the studies of a man facing left, on the *recto* and *verso*, borrowed from a famous *ignudo* of the *Incendio del Borgo* by Raphael in the Vatican, they doubtless prepare the figure of Guillotin in the large drawing in the Louvre.
Prov.: David sale in 1826 (?); Montausan; E. Degas; gift of L.-A. and V. Prat to the Louvre subject to usufruct in 1995. ROSENBERG and PRAT, 2002, no. 106, repr.

22. *Two Sketchbook Pages: Group of Four Nude Men One of Whom Holds an Umbrella; Two Nude Men, Arms Raised, Three-Quarters Left*
Graphite pencil. 18.2 × 11.3 cm (each). Inv. RF 36942

For the large project *The Oath of the Jeu de Paume* (see no. 24), David thought of introducing in the upper section of the composition figures of common people who supposedly attended the event. Since it takes place during a storm (invented by the artist, but which allowed him to show lightning striking the chapel of the château), several of these anonymous onlookers, tossed about by the wind, seek shelter under umbrellas and bend under the gusts of wind. Conforming to academic precepts, here David first studied them nude before dressing them as they appear in the large drawing. Two of the male figures on the left will become women in the final drawing.

Prov.: Fols 20v and 21r of sketchbook 4 (see no. 20). SÉRULLAZ, 1991, no. 226, repr.; ROSENBERG and PRAT, 2002, nos. 1456v and 1457r, repr.

23. *Sketchbook Page: Man Seen from Behind, Three-Quarters Right, Holding onto His Hat and Gripping a Pillar*
Graphite pencil. Squared in black chalk. 18.2 × 11.3 cm.
Inv. RF 36942

Study for one of the onlookers in the upper left of the gallery in *The Oath of the Jeu de Paume*; here again, the figure is first studied nude, then draped.

Prov.: Fol. 26r of sketchbook 4 (see no. 20). SÉRULLAZ, 1991, no. 226, repr.; ROSENBERG and PRAT, 2002, no. 1462r, repr.

24. *The Oath of the Jeu de Paume*
Pen, brown ink, with pen and black ink corrections in several places, brown wash and white heightening, over pencil lines. In the lower section parallel horizontal lines of perspective are still visible. Two fragments are cut out and mounted in the centre. Signed and dated lower right in pen and brown ink: *J.L. David faciebat anno 1791.* 66.0 × 101.2 cm. Inv. RF 1914

This famous drawing illustrates one of the founding episodes of the French Revolution, when the Third Estate deputies at the States General, on 20 June 1789, decided to form a National Assembly and not to disperse before giving France a constitution. The painting commissioned from David to celebrate the event was never completed. Versailles holds a large surviving fragment in which only a few heads are painted; by contrast, David completed the entire drawing in May 1791, and prints were published. We recognize the astronomer Bailly, at centre, perched on

a table, with the three ecclesiastics embracing in front of him, and several groups of figures, both famous and unknown: Barère, Sieyès, Robespierre, Dubois-Crancé, Mirabeau and Barnave. Some of these men had entirely lost power or credibility by mid-1791, which is probably one of the reasons the painting was never completed. But the drawing magnificently evokes a moment of national unanimity, which is shared, in the upper galleries, by the ensemble of the French population (see nos. 22 and 23).

Prov.: Redeemed by the heirs at the David sale of 1826; Jules David-Chassagnolle bequest to the Louvre in 1886; on deposit from the Louvre to Versailles. SÉRULLAZ, 1991, no. 197, repr. and colour pl.; ROSENBERG and PRAT, 2002, no. 118, repr.

25. *Two Sketchbook Pages: A Man and a Child near a Table*
Graphite pencil. 18.2 × 11.3 cm. (each). Inv. RF 36942

Between late 1791 and the spring of 1792, David thought about a painting commissioned by the Constituent Assembly, *Louis XVI Presenting the Constitution to the Dauphin.* Although he subsequently would deny having envisaged this project ("Mind you", he claimed, "the painter of *Brutus* was not born to paint kings"), several sketches of the present sketchbook evidence his interest in the subject. In the one on the left, the king, studied nude, shows the crown to the Dauphin; in the one on the right, he has him read the constitution of the kingdom.

Prov.: Fols 38v and 39r of sketchbook 4 (see no. 20). SÉRULLAZ, 1991, no. 226, repr.; ROSENBERG and PRAT, 2002, nos. 1473v and 1474r, repr.

26. *Marie-Antoinette Led to Her Execution, Seated in Left Profile*
Pen, brown ink. Inscription, in the hand of Soulavie, former owner of the drawing, below the mount: *Portrait de Marie Antoinette reine de france conduite / au Supplice; dessiné à la plume par David Spectateur du Convoi § placé sur la fenêtre avec la citoyenne jullien epouse du representant jullien, de qui je tiens cette piece.* [Portrait of Marie-Antoinette queen of France led to her execution; drawn in pen by David Onlooker of the convoy § placed at the window with the citizen Jullien wife of the representative Jullien, from whom I received this piece]. 14.8 × 10.1 cm. Inv. 3599 D.R.

An extremely famous drawing, but whose attribution is questioned by some experts, this sheet continues to be the object of

endless discussion. It is striking as much for the swiftness of the hand as for the impression of truth it emanates. It was on 16 October 1793, right in the middle of the Reign of Terror, that the former queen of France was guillotined.

Prov.: M.-A. Jullien; J.-L. Soulavie; baron Edmond de Rothschild; bequest to the Louvre, entered in 1936. SÉRULLAZ, 1991, no. 198, repr.; ROSENBERG and PRAT, 2002, no. 122, repr.

27. *The Triumph of the French People*
Graphite pencil, pen, black ink, grey wash over four joined pieces of cream-coloured paper. Squared in graphite pencil with numbering. On the *verso*, in pen and brown ink: *Légère esquisse pour le char.* 21.0 × 44.0 cm. Inv. RF 71

In the early months of 1794 David designed two large drawings (the second is held in Paris, Musée Carnavalet, ROSENBERG and PRAT, 2002, no. 129, repr.) on the theme of this triumph, doubtless for an opera curtain. The French People, represented in the guise of Hercules, is seated on a chariot holding on its lap Liberty and Equality; in front are the four allegorical figures of Science, Art, Trade and Plenty. His chariot is crushing the emblems of the monarchy and causing the scramble and flight, on the left, of the representatives of the *ancien régime*. On the right, heroes of liberty, antique (Cornelia and her sons the Gracchi, Brutus) or modern (William Tell and his son, Marat, Le Peletier de Saint-Fargeau), raise palms behind the chariot. The composition, unfolding like a frieze, despite a certain artlessness, faithfully reflects David's commitment to the most determined members of the Montagne, shortly before Thermidor.

Prov.: J.-E. Gatteaux; gift to the Louvre in 1873. SÉRULLAZ, 1991, no. 199, repr.; ROSENBERG and PRAT, 2002, no. 128, repr.

28. *Homer Reciting the "Iliad" to the Greeks*
Graphite pencil, corrected in pen, black ink, and partly in red chalk, brush, grey wash. Inscription with the tip of the brush, grey wash, below on the parchment: *chant / vingt / quatre / Iliade …* 27.1 × 34.5 cm. Inv. RF 789

Imprisoned in the Luxembourg in 1794 after the fall from power of Robespierre on 9 Thermidor, David composed two drawings (the other is also conserved in the Louvre) relating to Homer; in the background he placed the building where, in his words, he was held

"in vinculis", meaning "in irons". The allegory is obvious; removed from politics forever, the man of art (here the founding writer, and, in reference to David, the painter) relies on public generosity: on the right, maidens bring him something to eat.

Prov.: Perhaps in the David sale of 1826 (?); A.-C.-H. His de la Salle; gift to the Louvre in 1878. SÉRULLAZ, 1991, no. 202, repr., colour pl. II and colour detail on the cover; ROSENBERG and PRAT, 2002, no. 145, repr.

29. *The Intervention of the Sabine Women*
Black pencil, corrected in pen and black ink, grey wash and white heightening on two joined sheets of beige paper, with five rejoined fragments. Squared in black pencil. On the *verso*, on one of the joined sheets of paper, *Fragment of a Study of a Male Head, Three-Quarters Right, Eyes Closed.* 25.7 × 34.0 cm. Inv. RF 5200

In September 1794, during his captivity in the Luxembourg, David formed this idea of a painting he would not complete until 1798 or 1799. The subject clearly illustrates a broader theme, the restoring of civic peace, to which the artist decided to devote himself after his involvement with the members of the Montagne came to naught. We see the Roman Hersilia, at centre, intervening between Romulus on the right and Tatius, chief of the Sabines, on the left. A great many other drawings, including a general view (see no. 32), will mark the evolution of this masterpiece.

Unfortunately cut down by David himself who had to join two sheets to draw the overall view of his composition on the other side, the magnificent study of a face on the *verso* is probably related to a lost painting the artist executed in 1793, *Portrait of Le Peletier de Saint-Fargeau.*

Prov.: Espercieux; Mlle Gasnier; Mme Dey; Mme Damour; A. Beurdeley; purchased by the Société des Amis du Louvre at the 9th Beurdeley sale, Paris, Galerie Georges Petit, 30 November–2 December 1920, no. 108, and offered to the museum. SÉRULLAZ, 1991, no. 202, repr.; ROSENBERG and PRAT, 2002, no. 146, repr.

30. *Portrait of an Unknown Person, Half-Length, Right Profile*
Pen, black ink, grey wash and faint white heightening over black pencil. Circular. Signed with pen in black ink lower right: *L. David.* D. 18.4 cm. Inv. RF 4233

David was imprisoned a second time, in June–July 1795, by order of the Convention, after the Jacobin uprising of 9 Prairial year III; he was in the company of more than a dozen of his friends of the Montagne in the Quatre-Nations prison, and that is where he drew the incisive portraits of most of them, in round medallions (see Rosenberg and Prat, 2002, nos. 147–155). The Louvre holds but one drawing from this series, and the sitter, who in the past was believed to be his former comrade Dubois-Crancé (who had joined the moderates long before Thermidor), has returned to anonymity; his costume seems to suggest a personality who would have had military responsibilities.

Prov.: H. Destailleur; marquis de Biron; purchased by the Louvre at the Biron sale, Paris, Galerie Georges Petit, 9 June 1914, no. 13, repr. Sérullaz, 1991, no. 204, repr.; Rosenberg and Prat, 2002, no. 153, repr.

31. *Sketchbook Page: Group of Four Women and Head of a Man in Left Profile*
Graphite pencil. 13.6 × 17.6 cm. Inv. RF 9137

In this sketchbook, largely devoted to the evolution of the painting of the *Sabines*, this sheet treats the central group of the composition. Borrowed from an engraving of Marcantonio Raimondi, the head of the youth will be used for the figure on the right in the painting, donning a Phrygian cap.

Prov.: Fol. 62v of sketchbook 5, doubtless from the David sale of 1826; Bonaparte family; Thibaudeau family; marquis Philippe de Chennevières; P.-A. Chéramy; É. Moreau-Nélaton; gift to the Louvre in 1927. Sérullaz, 1991, no. 227, repr.; Rosenberg and Prat, 2002, no. 1551v, repr.

32. *The Intervention of the Sabine Women*
Pen, brown and black inks, grey wash and white heightening over black pencil, on three joined sheets. Squared in black pencil. 47.6 × 63.6 cm. Inv. 26183

The second general drawing, perhaps from late 1795, for the painting of the *Sabines* (Paris, Louvre), this large study is far closer to the final execution than no. 29; the figures are still clothed, whereas the male figures will be nude in the painting.

Prov.: J.-A.-D. Ingres; gift to the Louvre in January 1856. Sérullaz, 1991, no. 203, repr.; Rosenberg and Prat, 2002, no. 158, repr.

33. *Bonaparte Standing, with Horses and Horsemen behind Him*
Brush, grey wash over graphite pencil on beige paper. 30.0 × 21.0 cm. Inv. RF 52524

As soon as he met Bonaparte, probably in late 1797, David claimed he had found in him his "hero". He almost straightaway began the *Portrait of General Bonaparte*, a painting of which only a fragment survives, and in which only a section is completed, one of the most renowned pieces of the Beistegui donation to the Louvre in 1942. We know of two preparatory drawings for this composition, one representing Bonaparte standing by his horse held by a page (Paris, private coll.; Rosenberg and Prat, 2002, no. 174, repr.), and the present sheet, which has just entered the Louvre.

Prov.: Perhaps in the David sale of 1826; Galerie Coatalem; purchased by the Louvre in 2001. Rosenberg and Prat, 2002, no. 174 *bis*, repr.

34. *Two Sketchbook Pages: Studies of Horses and Horsemen*
Black pencil and graphite pencil. 13.6 × 17.6 cm (each). Inv. RF 9137

In the notebook of sketches for the *Sabines* (see no. 31), David devoted several sheets to studies of horses and horsemen that can be considered studies for the warriors in the background of the *Sabines* as well as preparatory studies for a slightly later painting, *Bonaparte at the Grand Saint-Bernard*, an equestrian portrait evoking the second Italian campaign and painted in four versions (1800–1801; the first version is conserved at the Musée national du Château de Rueil-Malmaison).

Prov.: Fols 30v and 31r of sketchbook 5 (see no. 31). Sérullaz, 1991, no. 227, repr.; Rosenberg and Prat, 2002, nos. 1520v and 1521r, repr.

35. *Two Sketchbook Pages: Napoleon Standing in Front of a Throne*
Graphite pencil. 17.1 × 10.9 cm (each). Inv. RF 41385

In 1805 David executed *Portrait of Napoleon Wearing Imperial Robes*, destined for the court of Genoa, a painting that displeased the Emperor and is now lost; the museum in Lille has a painted sketch of it. A dozen sheets of the present sketchbook are devoted to that composition.

Prov.: Fols 8v and 9r of sketchbook 6. Doubtless part of the David sale of 1826; Jules David-Chassagnolle; A. France; duc de Trévise;

G. Lévy; purchased by the Société des Amis du Louvre at the Lévy sale, Paris, Hôtel Drouot, 6 May 1987, no. 19, and offered to the museum. SÉRULLAZ, 1991, no. 228, repr.; ROSENBERG and PRAT, 2002, nos. 1560v and 1561r, repr.

36. *Napoleon Crowning Himself, Pope Pius VII Seated behind Him*
Black pencil on beige paper, very faint traces in pen and brown ink. Arched at the top. Squared in graphite pencil. Signed in black pencil, below toward the left: *L. David. f.* 29.3 × 25.2 cm. Inv. RF 4377

When David received the commission of the *Sacre of Napoleon*, a painting that was intended to commemorate the founding event of the Empire on 2 December 1804, he first planned to represent the moment when Napoleon crowned himself, with the Empress Josephine kneeling before him. However, after painting the figure corresponding to this astonishing drawing, he erased it, probably on the advice of Gérard, and chose to depict the Emperor crowning his wife instead. But a few general or detail studies preparatory to the first version are conserved. This famous sheet is particularly remarkable, contrasting the energy of the soldier-monarch, his hand pressing the sword that won him the conquest of power, to the extreme passivity of the pope; David would also modify the latter's attitude, in the painting shown raising his hand in blessing.
Prov.: I.-E.-M. Degotti; E. Wattier; Cottenet; purchased from M. Millet by the Louvre in 1917. SÉRULLAZ, 1991, no. 208, repr.; ROSENBERG and PRAT, 2002, no. 198, repr.

37. *Sketchbook Page: Three Prelates, Full-Front*
Black pencil. 17.1 × 10.9 cm. Inv. RF 41385

Sketchbook 6 contains a great many studies for the *Sacre*, which should also be called *The Crowning of Josephine* (see no. 36); this one lays out the group of ecclesiastics at the centre of the background of the composition, visible between Napoleon and Josephine. Studies of this type should probably be dated to 1805.
Prov.: Fol. 13r of sketchbook 6 (see no. 35). SÉRULLAZ, 1991, no. 228, repr.; ROSENBERG and PRAT, 2002, no. 1565r, repr.

38. *The Empress Josephine and Her Ladies-in-Waiting*
Black pencil and graphite pencil. Graphite pencil inscription at

lower centre: *L. David. f.* Squared in graphite pencil.
27.2 × 39.2 cm. Inv. RF 35514

Linked to the composition of the *Sacre*, the status of this drawing is the object of some controversy: is it indeed an original by David; does it belong to the group of preparatory studies executed for the first version of the painting; or for the version David did in Brussels during his exile (today conserved at Versailles), and for which he drew a number of figures "from memory"?
Prov.: Mme P. Goujon bequest to the Louvre in 1971. SÉRULLAZ, 1991, no. 209 and colour pl. 8; ROSENBERG and PRAT, 2002, no. 382, repr.

39. *Two Sketchbook Pages: Couple Striding toward the Right and Man in Left Profile; Studies of Ecclesiastics and Nude Man*
Graphite pencil. Inscription, in David's hand, on the right folio, in black chalk, upper left: *vieux maîtres / 2. Volume.*
17.1 × 10.9 cm (each). Inv. RF 41385

The left folio features a study not retained for the next number; the right one probably borrows figures from one of the albums called "Old Masters in wood" at the Bibliothèque nationale from which David drew several of the figures in the *Sacre*.
Prov.: Fols 40v and 41r of sketchbook 6 (see no. 35). SÉRULLAZ, 1991, no. 228, repr.; ROSENBERG and PRAT, 2002, nos. 1592v and 1593r, repr.

40. *The Reception of the Emperor and the Empress at the Hôtel de Ville of Paris*
Pen, black ink, grey wash, corrected in pen and brown ink, over graphite pencil. Three fragments of rejoined paper. Squared in graphite pencil. Signed and dated in pen and black ink lower right: *David f. et inv. / 1805.* 26.1 × 40.6 cm. Inv. RF 1916

With the commission for the *Sacre*, David was given that of three other paintings commemorating the celebrations of December 1804: *The Enthronement*, which was never even begun; *The Distribution of the Eagle Standards* (see the next three numbers); and *The Reception at the Hôtel de Ville*, which did not go beyond the drawing stage, this being the most finished version. The ceremony took place on 16 December 1804.
Prov.: David sale, Paris, 17 April 1826 and following days, no. 33;

redeemed; Jules David-Chasagnolle bequest to the Louvre in 1886. SÉRULLAZ, 1991, no. 206, repr.; ROSENBERG and PRAT, 2002, no. 203, repr.

41. *Sketchbook Page: Victory in Flight toward the Left*
Black pencil. Black chalk inscription, in David's hand, below: *cette figure était destinée à entrer / dans le tableau du couronnement* (these two words erased) *des aigles. C'est / l'empereur qui ne l'a pas Voulu, on Voit / par l'attitude des maréchaux qu'elle étoit indispensable.* [This figure was destined to appear in the painting of the coronation of the eagles. It was the Emperor who did not want it, we see by the attitude of the *maréchaux* that it was indispensable]. 11.1 × 18.6 cm. Inv. RF 23007

Rejected study for *The Distribution of the Eagle Standards* (see no. 43).
Prov.: Fol. 12v of sketchbook 7; David sale, Paris, 17 April 1826 and following days; A. Didot; F. Barrias; E. Pelletan; A. France; D. David-Weill, gift to the Louvre in 1932. SÉRULLAZ, 1991, no. 231, repr.; ROSENBERG and PRAT, 2002, no. 1608v, repr.

42. *Sketchbook Page: Two Nude Men Running toward the Left*
Black pencil. Squared in black pencil. 25.5 × 20.4 cm. Inv. RF 9136

The study may have been used, like many others, both for the group of colonels climbing the steps in *The Distribution of the Eagle Standards* and for the Greek warriors of Leonidas, which David was preparing during the same period; the figure in the foreground is obviously borrowed from the *Mercury* by Giambologna.
Prov.: Fol. 31r of sketchbook 12; Mme Mongez; H. Destailleur; É. Moreau-Nélaton, gift to the Louvre in 1927. SÉRULLAZ, 1991, no. 229, repr.; ROSENBERG and PRAT, 2002, no. 1873r, repr.

43. *The Distribution of the Eagle Standards*
Pen, black ink, grey wash and white heightening over graphite pencil on beige paper. Signed and dated in pen and black ink lower right: *David / X bre 1808.* 18.2 × 29.1 cm. Inv. RF 1915

This finished drawing for *The Distribution of the Eagle Standards* (Versailles, painting dated to 1810) only partially matches the final painting. In the painting commemorating the event of 9 December 1804, five days after the anointing, Napoleon refused to allow the inclusion of the allegory of Victory that, on the right, distributes crowns to the officers of his army. This explains the inscription written by David on his earlier drawing (see no. 41). Furthermore, the Emperor demanded the suppression of the figure of Josephine seated on the left, since the painting was not completed until after his divorce and his second marriage to Marie-Louise.
Prov.: David sale, Paris, 17 April 1826 and following days, no. 32; Jules David-Chassagnolle bequest to the Louvre in 1886. SÉRULLAZ, 1991, no. 211, repr.; ROSENBERG and PRAT, 2002, no. 281, repr.

44. *Portrait of M. and Mme Alexandre Lenoir*
Black chalk and graphite pencil on two joined sheets. Signed and dated in black chalk and graphite pencil under each portrait: *L. David f. 1809.* 15.5 × 21.4 cm. Inv. RF 5218

Founder of the Musée des Monuments français during the Revolution, Lenoir was a close friend of David, who completed his painted portrait in 1817 (Paris, Louvre).
Prov.: Lenoir family; purchased by the Louvre in 1921. SÉRULLAZ, 1991, no. 213, repr.; ROSENBERG and PRAT, 2002, no. 222, repr.

45. *The Departure of Hector*
Pen, black ink, grey wash and white heightening over black pencil on beige paper. Signed and dated in pen and brown ink, lower right: *L. David f. / 1812.* 22.1 × 29.1 cm. Inv. RF 1919

This drawing as well as the next number may well be projects for two ceilings in the Louvre that were never executed. The subject, drawn from the *Iliad*, was often rendered by David; its graphic style already prefigures the eccentricities of the period of his exile.
Prov.: David sale, Paris, 17 April 1826 and following days, no. 28; J. David-Chassagnolle bequest to the Louvre in 1886. SÉRULLAZ, 1991, no. 216, repr.; ROSENBERG and PRAT, 2002, no. 305, repr.

46. *Venus Wounded by Diomedes Complains to Jupiter*
Pen, black ink, grey wash and white heightening over black pencil on beige paper. Signed and dated on the pedestal in pen and black ink: *L. David. 1812.* 23.9 × 18.2 cm. Inv. RF 1918

See the previous number.
Prov.: David sale, Paris, 17 April 1826 and following days, no. 29; J. David-Chassagnolle bequest to the Louvre in 1886. SÉRULLAZ, 1991, no. 215, repr.; ROSENBERG and PRAT, 2002, no. 306, repr.

47. *Leonidas at Thermopylae*
Pen, black ink, grey wash and white heightening over black pencil. Signed and dated in pen and black ink lower left: *L. David. / 1813*. 20.9 × 28.1 cm. Inv. 26080

In the very protracted genesis of *Leonidas* (Louvre, dated to 1814), which lasted almost fifteen years, this general view reflects an almost final stage. A few figures will be further altered.
Prov.: David sale, Paris, 17 April 1826 and following days, no. 27; purchased at this sale by the Louvre. SÉRULLAZ, 1991, no. 221, repr.; ROSENBERG and PRAT, 2002, no. 316, repr.

48. *Two Sketchbook Pages: Cupid and Psyche*
Black pencil. 17.2 × 11.3 cm (each). Inv. RF 6071

Two studies for a painting commissioned in 1813 by Sommariva, *Cupid and Psyche* (Cleveland, The Cleveland Museum of Art; completed in 1817); on the right, a faint copy after an antiquity in the Louvre, the *Cincinnatus*.
Prov.: Fols 47v and 48r of sketchbook 11; David sale of 1826 (?); Coutan-Hauguet; J. M. de Zoubaloff; gift to the Louvre in 1924. SÉRULLAZ, 1991, no. 230, repr.; ROSENBERG and PRAT, 2002, nos. 1824v and 1825r, repr.

49. *Portrait of Pope Pius VII*
Graphite pencil. Graphite pencil inscriptions lower centre: *PIE VII* and below, erased: *Pie Sept*. On the verso, in graphite pencil, two male heads, two caricatured heads, and a nude man. 21.4 × 19.3 cm. Inv. RF 41199

In February–March 1805, shortly after the anointing, David executed the portrait of the pope (Paris, Louvre). This drawing, which repeats it with variants, may have been executed by David in Brussels during his exile, but its dating is still questioned.
Prov.: Originally mounted in sketchbook 12 (see no. 42); Wildenstein; Sonnenberg; purchased from the Galerie Segoura by the Louvre in 1985. SÉRULLAZ, 1991, no. 205, repr.; ROSENBERG and PRAT, 2002, no. 358, repr.

50. *Sketchbook Page: The Rape of Lucretia*
Black pencil. 11.1 × 18.6 cm. Inv. RF 23007

At the end of his life, during his exile in Brussels, David devoted himself to two quite similar compositions, which would not go beyond the drawing stage: *Mars and Rhea Silvia* and *The Rape of Lucretia*; a more advanced drawing of the same subject, for a long time known through an engraving by Daems, appeared recently (ROSENBERG and PRAT, 2002, no. 450, repr.).
Prov.: Fol. 23r of sketchbook 7 (see no. 41); SÉRULLAZ, 1991, no. 231, repr.; ROSENBERG and PRAT, 2002, no. 1619r, repr.

* The numbers given to the reassembled albums and to the sketchbooks are those of the ROSENBERG and PRAT 2002 catalogue.

BIBLIOGRAPHY

BORDES, 1983
Ph. Bordes, *"Le Serment du Jeu de Paume" de Jacques-Louis David: le peintre, son milieu et son temps, de 1789 à 1792.* Paris: 1983.

BORDES and POUGETOUX, 1983
Ph. Bordes and A. Pougetoux, "Les portraits de Napoléon en habits impériaux par Jacques-Louis David", *Gazette des beaux-arts*, July–August 1983, pp. 21–34.

BROOKNER, 1980
A. Brookner, *Jacques-Louis David.* London: 1980.

CANTALOUBE, 1860
A. Cantaloube, "Les dessins de Louis David", *Gazette des beaux-arts*, September 1860, pp. 285–303.

CANTINELLI, 1930
R. Cantinelli, *Jacques-Louis David 1748–1825.* Paris–Brussels: 1930.

CHENNEVIÈRES, 1897
Ph. de Chennevières, "Une collection de dessins d'artistes français." *L'Artiste*, chapter XXII, December 1897, pp. 410–25.

COSNEAU, 1983
Cl. Cosneau, "Un grand projet de J.-L. David (1789–1790). L'Art et la Révolution à Nantes", *La Revue du Louvre*, no. 4, 1983, pp. 255–63.

CROW, 1995
Th. Crow, *Emulation. Making Artists for Revolutionary France.* New Haven–London: 1995.

DAVID, I, 1880; II, 1882
J.-L. J. David, *Le peintre Louis David, 1748–1825.* I. *Souvenirs et documents inédits.* II. *Suite d'eaux-fortes d'après ses œuvres gravées par J.-L. Jules David son petit-fils.* Paris: I, 1880; II, 1882.

DELÉCLUZE, 1855
E.-J. Delécluze, *Louis David son école et son temps. Souvenirs.* Paris: 1855; 2nd ed. with preface and annotations by J. P. Mouilleseaux. Paris: 1983.

DOWD, 1948
D. L. Dowd, *Pageant-Master of the Republic: Jacques-Louis David and the French Revolution.* New York: 1948.

FLORISOONE and HUYGHE, 1948
M. Florisoone and R. Huyghe, *David. Exposition en l'honneur du deuxième centenaire de sa naissance.* Exhib. cat. (Paris, Orangerie des Tuileries–Versailles, Musée du Château, June–September 1948). Paris: 1948.

HAUTECŒUR, 1954
L. Hautecœur, *Louis David.* Paris: 1954.

HERBERT, 1972
R. L. Herbert, *David, Voltaire, "Brutus" and the French Revolution: An Essay in Art and Politics.* London: 1972.

HOLMA, 1940
Kl. Holma, *David. Son évolution et son style.* Paris: 1940.

HOWARD, 1975
S. Howard, *Sacrifice of the Hero: The Roman Years; A Classical Frieze by Jacques-Louis David.* Sacramento, Calif.: 1975.

JOHNSON, 1993
D. Johnson, *Jacques-Louis David: Art in Metamorphosis.* Princeton: 1993.

LAJER-BURCHARTH, 1999
E. Lajer-Burcharth, *Necklines: The Art of Jacques Louis David after the Terror.* New Haven: 1999.

LAPAUZE, 1913
H. Lapauze, *David et ses élèves.* Exhib. cat. (Paris, Palais des Beaux-Arts de la Ville de Paris, 7 April–9 June 1913). Paris: 1913.

LAVEISSIÈRE, 2004

S. Laveissière, *Le Sacre de Napoléon peint par David*. Exhib. cat. (Paris, musée du Louvre, 21 October 2004–17 January 2005). Milan: 2004.

LEE, 1969

V. Lee, "Jacques-Louis David: The Versailles Sketchbook", *The Burlington Magazine*, 111, no. 793, April 1969, pp. 197–208; 111, no. 795, June 1969, pp. 360–69.

MICHEL, (1989) 1993

R. Michel (edited by), *Actes du colloque David contre David* (Paris, Musée du Louvre, Auditorium, 6–10 December 1989). Paris: 1993.

MONGAN, 1975

A. Mongan, "Some Drawings by David from His Roman Album I", *Études d'art français offertes à Charles Sterling, réunies et publiées par Albert Châtelet et Nicole Reynaud*, pp. 319–26. Paris: 1975.

NASH, 1973

S. A. Nash, "The Drawings of Jacques-Louis David: Selected Problems", Ph.D. Dissertation, Stanford University: 1973.

ROBERTS, 1989

W. Roberts, *Jacques-Louis David, Revolutionary Artist: Art, Politics, and the French Revolution*. Chapel Hill, N.C.: 1989.

ROSENBERG, 1974

P. Rosenberg, "Un ensemble de dessins de David au musée des Arts décoratifs de Lyon", *La Revue du Louvre*, no. 6, 1974, pp. 421–28.

ROSENBERG and PRAT, 2002

P. Rosenberg and L.-A. Prat, *Jacques-Louis David, 1748–1825, Catalogue raisonné des dessins*. 2 vols. Milan: 2002.

ROSENTHAL, [1904]

L. Rosenthal, *Louis David*. Paris: [1904].

SAHUT and MICHEL, 1988

M.-C. Sahut and R. Michel, *David, l'art et le politique*. Paris: 1988.

SCHNAPPER, 1980

A. Schnapper, *David témoin de son temps*. Fribourg: 1980 (Eng. ed., 1982).

SCHNAPPER and SÉRULLAZ, 1989

A. Schnapper and A. Sérullaz, *Jacques-Louis David 1748–1825*. Exhib. cat. (Paris, Musée du Louvre–Versailles, musée du château, 26 October 1989–12 February 1990). Paris: 1989.

SÉRULLAZ, (1972) 1975

A. Sérullaz, "À propos de quelques dessins de Jacques-Louis David pour 'Mars désarmé par Vénus et les Grâces'", *Bulletin des Musées royaux des Beaux-Arts de Belgique*, 21, nos. 1–4 (1972) 1975, pp. 107–15.

SÉRULLAZ, 1980

A. Sérullaz, "Dessins de Jacques-Louis David", *La donation Suzanne et Henri Baderou au Musée de Rouen. Peintures et dessins de l'École française. Études de la Revue du Louvre et des Musées de France*, no. 1, 1980, pp. 100–5.

SÉRULLAZ, 1983

A. Sérullaz, in *Autour de David. Dessins néo-classiques du Musée des Beaux-Arts de Lille*, Exhib. cat. edited by A. Scottez-de Wambrechies (Lille, Musée des Beaux-Arts, 1983). Lille: 1983.

SÉRULLAZ, 1991

A. Sérullaz, *Musée du Louvre, Cabinet des dessins. Inventaire général des dessins. École française. Dessins de Jacques-Louis David, 1748–1825*. Paris: 1991.

SÉRULLAZ, MICHEL and VAN DE SANDT, 1981

A. Sérullaz, R. Michel and U. van de Sandt, *David e Roma*. Exhib. cat. (Rome, Académie de France, December 1981–February 1982). Rome: 1981.

VERBRAEKEN, 1973

R. Verbraeken, *Jacques-Louis David jugé par ses contemporains et par la postérité*. Preface by L. Hautecœur. Paris: 1973.

WILDENSTEIN, 1973

D. and G. Wildenstein, *Documents complémentaires au catalogue de l'œuvre de Louis David*. Paris: 1973.

Photographic Credits

RMN/Michèle Bellot: cover, page 2, nos. 1, 7, 9, 10–12, 15, 16, 18, 19, 27–30,
32, 38, 43, 47; RMN/Jean Gilles Berizzi: no. 40; RMN/Gérard Blot: nos. 24, 33, 36, 44–46;
RMN/Thierry Le Mage: nos. 2–6, 8, 13, 14, 17, 20–23, 25, 26, 31,
34, 35, 37, 39, 41, 42, 48–50.

Paper
This book is printed on Satimat naturel 170 g;
cover: ArjoWiggins Impressions Keaykolour Nature Schiste 250 g

Colour Separation
Cross Media Network s.r.l., Milan

Printed August 2005
by Arti Grafiche Bianca & Volta, Truccazzano, Milan, Italy,
for the Musée du Louvre, Paris, and for 5 Continents Editions, Milan